IMAGES
of America

SARATOGA

IMAGES
of America

SARATOGA

April Halberstadt and Katie Alexander
Saratoga History Museum

ARCADIA
PUBLISHING

Published by Arcadia Publishing
Charleston SC, Chicago IL, Portsmouth NH, San Francisco CA

Printed in the United States of America

Library of Congress Catalog Card Number: 2008936547

For all general information contact Arcadia Publishing at:
Telephone 843-853-2070
Fax 843-853-0044
E-mail sales@arcadiapublishing.com
For customer service and orders:
Toll-Free 1-888-313-2665

Visit us on the Internet at www.arcadiapublishing.com

For Tom Soukup and our daughters, Karen and Erica.

For Hans Halberstadt and for Justine, Hannah, Sterling, and Ella.

CONTENTS

ACKNOWLEDGMENTS

All historians stand on the shoulders of those who came before them. In Saratoga, we are indebted to Florence R. Cunningham who spent her lifetime making notes about her beloved community, and to her friend Frances Fox, who edited Florence's notes and created Saratoga's first history book, *Saratoga's First Hundred Years*. Florence left a lifetime of notes, artifacts, and the proceeds of her estate to establish a museum.

We are grateful to Melita Oden, who was the custodian of Florence's estate. Florence and Melita had the prudence to collect hundreds of photographs, writing information on the backs of these priceless images. Seeing their handwriting always reminds us of their foresight.

We are grateful to the board of the Saratoga Historical Foundation for authorizing the use of these images. Two board members in particular, Warren Heid and his school classmate Willys Peck, helped us with research material and insights. Their marvelous memories have been invaluable. They have blessed the West Valley with their many personal and civic contributions besides their chosen professions of architecture and journalism, respectively.

Thanks to Don Armstrong and Doug Anderson, museum volunteers who scanned hundreds of images, creating one of the museum's most important assets, the photographic database. We would not have taken on this project without this incredible asset.

Several Saratoga residents provided additional images: Ed Metivia from Ascension Church, Mike Cummings from the Church of Jesus Christ of Latter-day Saints–Saratoga, Mary Bogdanovich from St. Archangel Michael Serbian Orthodox Church, Gina Campanella from Prospect High School, Dave Anderson from the City of Saratoga, and Sue Mallory. And finally we acknowledge Hans Halberstadt and Tom Soukup, for their technical support, their counsel, and their affection. Thanks, sweeties.

All photographs are from the collection of the Saratoga Historical Foundation unless specifically noted. Many images come from the *Saratoga Citizen* Collection, a newspaper archive within the foundation's holdings.

INTRODUCTION

Welcome to Saratoga. This book is about the historic California village of Saratoga and how it grew and became a city. In this perfect little community dating to a time before California became a state, Saratoga residents know they live in the most wonderful place on earth. In the beginning, lumber, fruit, and tourism provided a substantial economic base. An influx of wealthy residents such as Sen. James Phelan from San Francisco provided the community with many cultural amenities. Saratoga traces its beginnings to 1848, and today the entire community is listed as California Landmark No. 435 in recognition of its rich historic heritage.

The earliest residents in the area were the Muwekma Ohlones, who established a substantial settlement in the heart of what later became Saratoga's business district. Like the American settlers of later days, the Ohlones recognized a beautiful site with tremendous economic potential. A lovely creek flows from the Santa Cruz Mountains into a grassy plain studded with enormous oak trees. The Ohlone village was established by the side of Saratoga Creek, with their pathway leading through the mountains to the Pacific Ocean.

The Spanish were aware of Saratoga's resources. Redwoods provided timber for the Santa Clara mission. A dairy for the mission was established on Saratoga Creek. Redwoods on the crest of the Santa Cruz Mountains offered economic opportunity, and Saratoga's first businesses were related to lumbering. Yankee settlers built water-powered gristmills and lumber mills, channeling the creek through a system of dams and flumes to power the mills. Two paper mills were also established, enterprises that provided substantial economic benefit in the 1880s.

Tourists were attracted to Saratoga. Wealthy San Francisco residents began building vacation houses in the area as early as 1866. Saratoga has several natural mineral springs, and a resort was built for visitors seeking health benefits. The resort was named Congress Springs after an extremely fashionable establishment in New York state. The mineral content of the local water was nearly identical to the springs of Saratoga Springs in New York.

Wealthy retirees discovered Saratoga, bringing cultural amenities to the area. A retired Congregationalist minister established the annual Blossom Festival, bringing thousands of tourists to Saratoga. The fruit industry became Saratoga's major enterprise, and another generation of residents built vacation homes. One less affluent new resident was Mary Day Brown, the widow of famed abolitionist John Brown. Quiet Saratoga offered the Brown family a refuge from the notoriety of the raid on Harper's Ferry.

Early residents discovered that the fertile soil and marvelous climate would support nearly every crop imaginable. The first crops were grains—barley straw was used in paper manufacture at the Saratoga paper mills—but orchards soon took their place. Saratoga became known for its peaches, prunes, and apricots. The California Prune and Apricot Growers Association became Sunsweet, widely known for the quality of its fruit products.

Saratoga was an early wine-growing region, made famous by the Paul Masson champagne cellars located in Saratoga until the 1980s. Today Saratoga is part of the Santa Cruz Mountain appellation, the first wine-growing area in America recognized as a region.

World War II brought tremendous change. After 100 years of bucolic existence, Saratoga was flooded by thousands of new residents taking jobs in nearby aerospace and electronics industries. In addition, the community was threatened by annexation as San Jose expanded its tax base. Hundreds of new homes meant families with children. The school system and local government struggled to keep up with the growth.

Faced with growth problems, Saratoga residents made some difficult land use and lifestyle decisions. Those radical choices have shaped the community into one of the wealthiest enclaves in California. Residents challenged conventional wisdom and decided to keep their rural lifestyle, excluding manufacturing from their tax base. They chose to keep taxes low by contracting local services such as police and fire protection.

When Saratoga built a new library, they staffed it from the Santa Clara County library system. These critical decisions have had some far-reaching benefits. Saratoga is now known for being fiscally conservative, for making children and family life a priority, and for being sensitive to its beautiful surroundings. Today Saratoga has an enviable reputation as a community that values education, the arts, and maintaining traditional values.

MY EARLIEST CHILDHOOD MEMORIES

Some of my earliest childhood memories are of Sunday afternoon walks that my parents, older brother and I would take in the hills behind Saratoga. This was in the late 1920's (I was born in 1923) when we lived at the end of Marion Avenue (Marion Road on the map).

The walk to the hillside vantage point where we could admire the view took us up a rather steep wooded ravine; taxing to childish limbs but definitely worth the effort, the view was an experience never to be forgotten. It was like looking at a toy village, with miles of orchards stretching into the distance.

That house, where we lived until 1932, was an ideal place for small children, bordered as it was on three sides by orchards. There was still some cultivating done with a horse-drawn plow, and the tractor that succeeded it was, for me, an endless source of fascination and the subject of many scrawled pictures in which I tried to capture the drama of its passage.

Little is left of this atmosphere, but the hills are eternal and memory is a potent force.

Willys Peck

Printed on a C&M Columbian No. 2, circa 1883
*Typeset in 10pt. Times Roman & Italic on a
1947 Linotype Model 5.*

On June 22, 2008, Saratoga's favorite writer and historian, Willys Peck, opened Peck's Printing Museum with a resurrected 1947 Mergenthaler Linotype. This reminiscence, typeset on the Linotype and printed on an 1883 C&M Columbian No. 2, was a souvenir of that event.

One

OVERVIEW
FROM VILLAGE TO CITY

Saratoga has done well. It is a small city, with only 30,000 or so residents, but it is now one of the most desirable communities in California. Its citizens know it is a beautiful place to live . . . wonderful climate, a lovely landscape, congenial neighbors. But the average resident is hard-pressed when asked what makes Saratoga so special and how this community preserves its special identity.

This first chapter is an overview of a few people and events that define our character. Saratoga has a remarkable past, making significant contributions to California history. Saratoga residents contribute to the broad pattern of Western history, from the early water-powered mill built by William Campbell to the dozens of patents held by modern residents.

Saratoga residents always worked very hard and demonstrated a commitment to strong moral values, to their families, and to their neighbors. If there is one major theme in Saratoga life, it is her citizens' willingness to spend their free time in projects that support the community. There are many examples of this selfless spirit, beginning with the Temperance Society's offer of their hall as the first public school, through decades of public service by the Saratoga Volunteer Fire Department, the Grange, the Madronia Cemetery Board, and the California Apricot and Prune Growers Association.

Saratoga encourages its children to participate in their community. Service is part of the local education programs. Busy parents take the time to work on projects with their children. Saratoga also takes time to smell its roses, appreciating music and the arts in community life. All of these small but loving acts add up over time. This first chapter is a quick glimpse of what makes Saratoga so special.

William Campbell knew surveying and mechanics when he came to California in 1846. He understood water power and with his brother built a flume a quarter-mile long to power his gristmill. Campbell made the first survey for San Jose, built the first thresher in the valley, and served as elder of the San Jose Methodist Church.

Lumbering was one of Saratoga's earliest industries, and harvesting the giant redwoods brought a rough crowd to early Saratoga. Some still recall tales of early saloons that characterized Saratoga, considered a very tough place because of the lumberjacks.

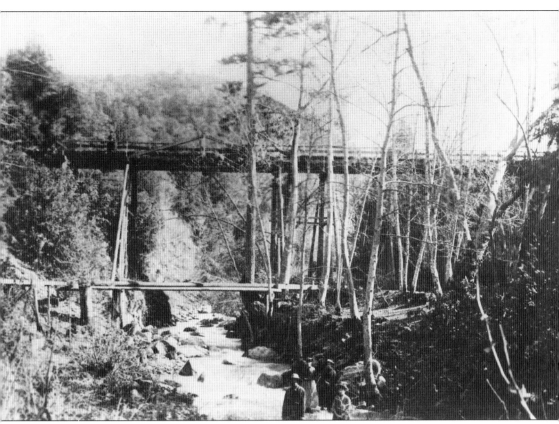

Not surprisingly, the lumber camp was first known as "Campbell's" and the creek was first called Campbell's Creek. William Campbell's flume can be seen as a structure under the original Long Bridge. The bridge itself was also an engineering marvel and was not replaced until 1902. It served decades of logging wagons, bringing logs from the hill to the lumber mills of Campbell and his partner, William Haun.

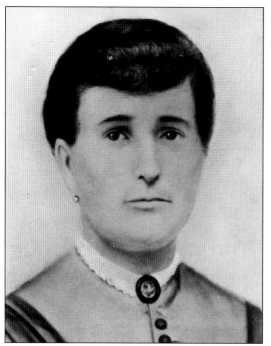

Hannah Barry McCarthy (1834–1893) was left with four small children when her husband, Martin, died in an accident in 1864. An enterprising woman, she built business buildings and residences in Saratoga's village. Some buildings were sold; others were rented. She donated a site for the Saratoga Grammar School on Oak Street and land for the adjacent Congregational church. Hannah McCarthy is considered the area's first developer.

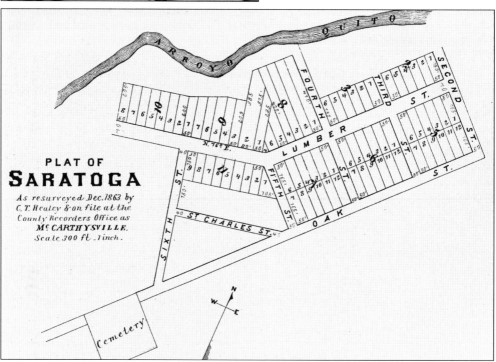

PLAT OF
SARATOGA
As resurveyed Dec.1863 by
C.T. Healey & on file at the
County Recorders Office as
M? CARTHYSVILLE.
Scale 300 ft.–1 inch.

Martin McCarthy, an Irish immigrant, did well in the Gold Rush. He found an Irish bride in San Jose, Hannah Barry, and they acquired a substantial tract of land in 1852. They registered and platted their land, naming the town after themselves, McCarthysville. The town was resurveyed in 1863 when Mexican land grants were adjudicated, but the lots remain identical to the earlier plat. Saratoga Village still retains many of its original property boundaries.

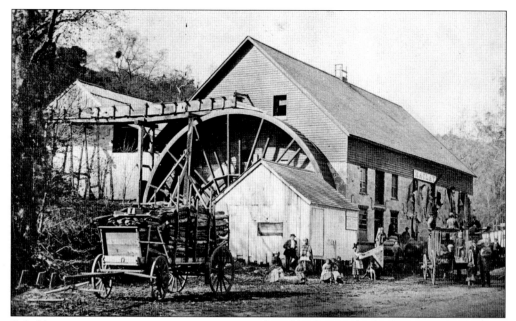

Reliable water power was an important commodity. Charles Maclay built a second mill and a tannery, using Saratoga Creek as his resource. His business burned in 1863, but Maclay rebuilt and expanded, including a store, tannery, gristmill, blacksmithing, and a tollgate. This photograph from 1872 shows his settlement, which he named Bank Mills. Today only one stone wall, a retaining wall near the entrance to Hakone, remains.

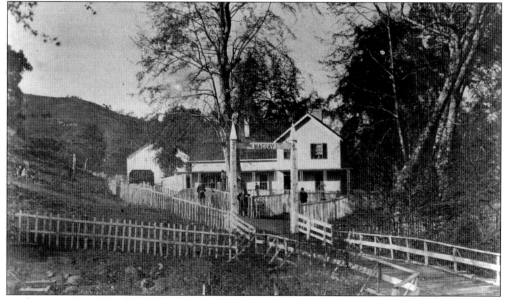

A charismatic personality, Charles Maclay was a powerful orator and respected politician. He organized the Republican Party in California and served two terms in the state assembly and two in the state senate. He helped found local institutions: University of the Pacific, the Saratoga-Pescadero Turnpike (State Highway 9), the First Methodist Church in San Jose, and San Jose Normal School. This impressive home on upper Big Basin Way was a local landmark for more than a century.

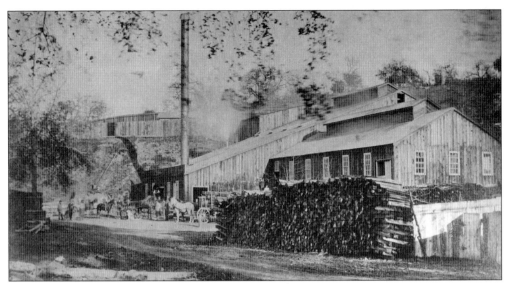

Close to water, straw, and wood, Saratoga also attracted paper manufacturers. The Saratoga Paper Mill was established in 1869 and flourished until 1883. They were the only Bay Area source for brown butcher's paper. In 1870, two employees started a mill nearby. Located across the creek, the Caledonia Pasteboard Mill manufactured cardboard until moving to Corralitos in 1880. The Saratoga Mill burned in 1883.

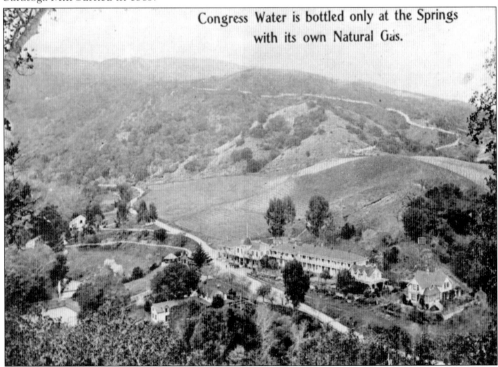

Congress Water is bottled only at the Springs with its own Natural Gas.

Saratoga's climate was very attractive to residents of cold, dreary San Francisco. Wealthy entrepreneurs Darius O. Mills and Alvinza Hayward built summer cottages at Congress Springs near Bank Mills. The hotel at Congress Springs had 63 rooms and several cottages. Owned by Lewis P. Sage, the resort had its own dairy, trout pond, orchard, and vineyard.

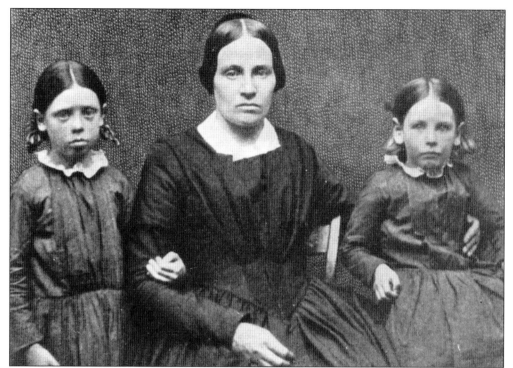

The family of abolitionist leader John Brown moved to Saratoga, a community sympathetic to the anti-slavery movement. Widow Mary Ann Day Brown and her two youngest daughters, Sarah and Ellen, moved to the Saratoga hills on Bohlman Road in 1881. Seventeen Brown family members are buried in the Madronia Cemetery. Here is Mary Ann Brown with Sarah (right) and Annie (another daughter) before the move to California.

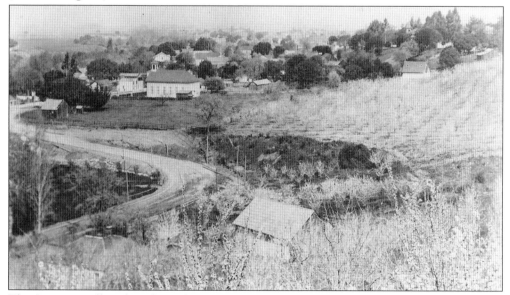

The Saratoga Village has always been considered one of California's most scenic little towns, nestled in a valley surrounded by orchards and vineyards. State Highway 9, designated as a Scenic Highway, is curving toward the original Sacred Heart Church.

The Reverend E. S. Williams, known as "Everlasting Sunshine" to the community, was a wealthy and influential Congregationalist minister who retired to Saratoga in 1896. Grateful for the end of a drought, he established Saratoga's Blossom Festival in 1900 in thanksgiving. By 1920, the event attracted thousands of visitors and lasted a week. The event was widely imitated and was held until World War II.

Although several of Santa Clara Valley's most notable agriculturalists were Saratoga pioneers, the local fruit industry became established later than orchards in San Jose and Santa Clara. Saratoga was noted as home to the largest prune orchard in the world when Glen Una covered more than 600 acres.

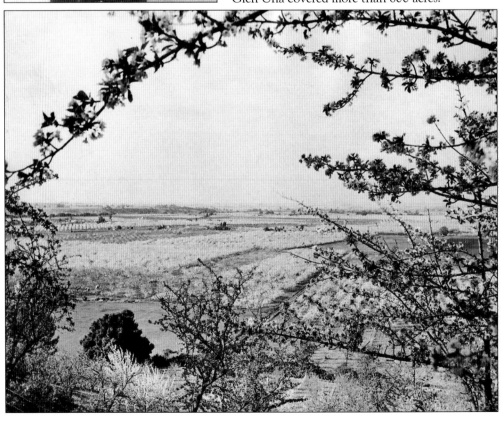

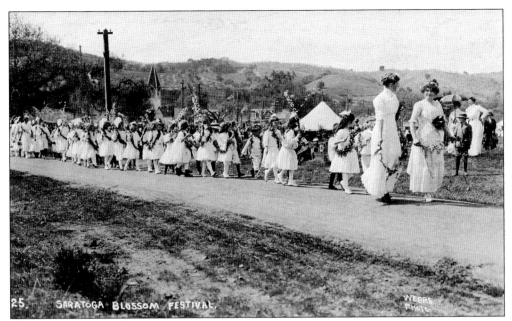

Saratoga schoolchildren from the Oak Street School parade to the Blossom Festival, making their way along rural Saratoga Avenue to the festival site. A children's chorus and a maypole dance were part of the festivities. The early festivals were held in a large open green in front of what is now the Foothill Club.

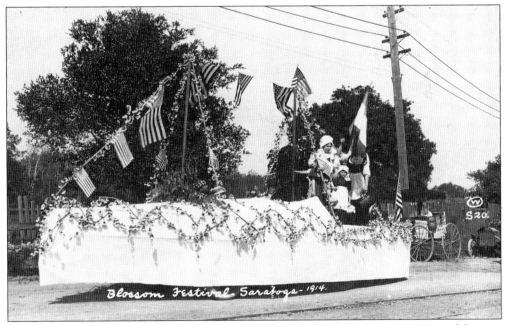

The annual Blossom Festival grew from a one-day festival of thanksgiving to a major celebration with a parade, floats, bands, and a week of festivities. Dignitaries such as the governor of California attended, and hundreds came to Saratoga to participate. The Saratoga economy prospered as a result of all of the tourists.

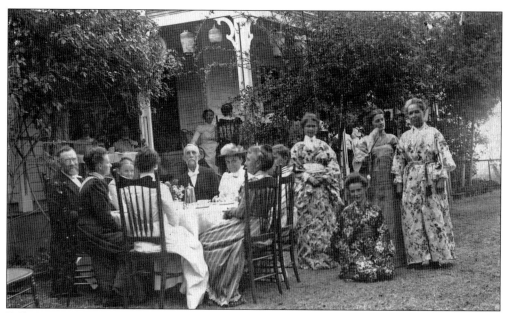

Bella Vista is one of the most beautiful estates in the West Valley and remained in the same family for over a century. Originally the 160-acre homestead of the Farwell family, Bella Vista was left to their cousins, the Charles Blaney family. The Blaneys demolished this house in 1917 and replaced it with a remarkable home designed by Willis Polk.

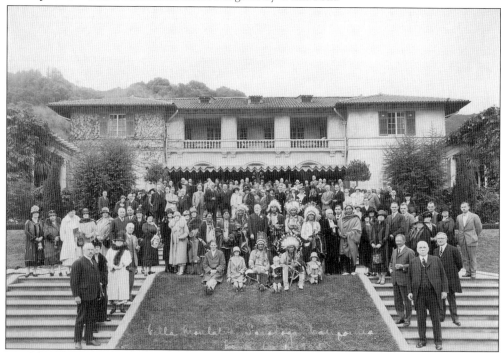

Wealthy James Duval Phelan was a mayor of San Francisco and later a senator with a summer home in Saratoga. Interested in poetry and the arts, Phelan's showplace was a mecca for talented writers and musicians. He enjoyed entertaining, and about 200 Native Americans were among his guests for this gathering.

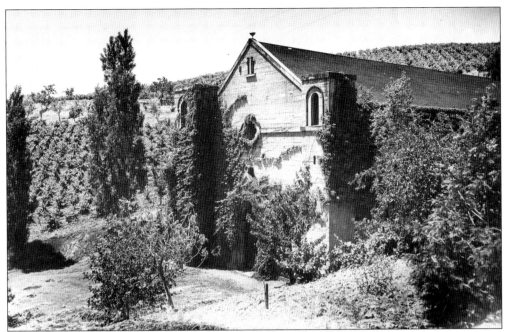

Paul Masson arrived in Santa Clara County in 1878 and began making wine in the New Almaden area. He became interested in making champagne and acquired the old Rodoni vineyard in Saratoga around 1900. In addition to champagne, he was noted for making dessert wines bottled in distinctive little heart-shaped flasks. The old winery site is now known as Mountain Winery and is an entertainment venue, and the wine operation itself has moved to the Central Valley and is owned by Constellation Brands.

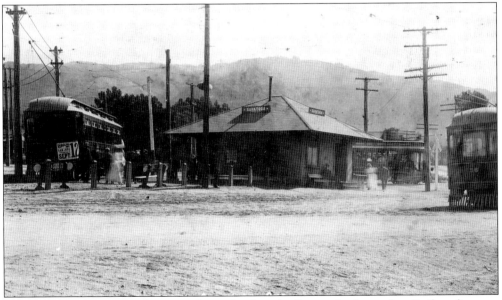

Rural Saratoga experienced a spurt of growth when the Peninsular Interurban Railway line was completed in 1903. With convenient access to San Jose and Los Gatos, Saratoga residents could enjoy living in a rural community while working in town. The trolley was a community fixture until 1933, when it was replaced with buses.

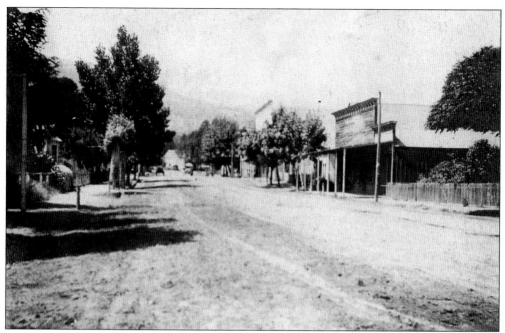

Saratoga is the gateway to the magnificent redwoods of Big Basin State Park, California's first and oldest state park. Saving the big trees marked a significant turning point in the development of California. Local residents proudly changed the name of their main thoroughfare from Lumber Street to Big Basin Way in 1927.

Luther Cunningham was a younger member in a large family, a circumstance that may have encouraged his creativity. Several older brothers managed the family orchards, so Luther was left to tinker and invent. His specialized farm implements and mechanical devices were manufactured by the Food Machinery Company (FMC), and his patents supported a major new industry: food processing.

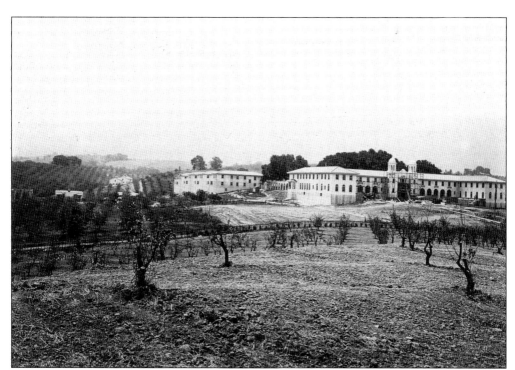

The International Order of Odd Fellows (IOOF) built a retirement home in the rolling Saratoga foothills in 1912. The institution was completely self-sufficient with its own orchards and farm. Known today as the Saratoga Retirement Community, it gives residents several living options including apartments and townhouses.

The Memorial Arch in Blaney Plaza is a Saratoga icon, representing Saratoga's compassion, generosity, and artistic sensibility. Saratoga developer Charles Blaney donated the land and commissioned Bruce Porter to design this monument commemorating the ultimate sacrifice of six Saratoga residents in World War I. Fifty-five residents of this tiny community served in World War I.

The Foothill Club was organized in 1907 by 12 ladies who liked stimulating conversation. As their group grew, they needed a place to meet and commissioned architect Julia Morgan to design their clubhouse. Here is the group in 1910, enjoying a meeting held at the home of Jennie Farwell.

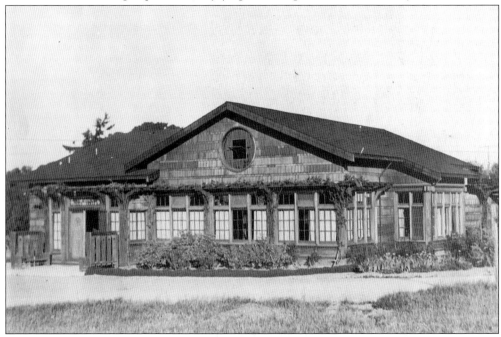

Architect Julia Morgan designed the Foothill Club at the invitation of her sorority sister and friend, Saratoga resident Grace Richards. The notable Morgan also designed the Federated Church, located just across the street from the Foothill Club, as well as three Saratoga residences.

Dorothea Johnston, a Broadway actress and producer, was invited to spend summers at the Saratoga Inn, a lodge owned by her mother. With her Broadway friends, Johnston produced entertainments for visitors in the Theatre of the Glade. She also trained many local people, including sisters Olivia De Havilland and Joan Fontaine, for careers in Hollywood. (Dorothea Lange photograph; gift of Olivia De Havilland.)

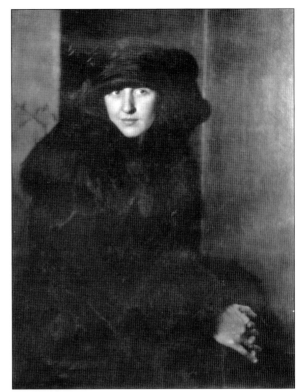

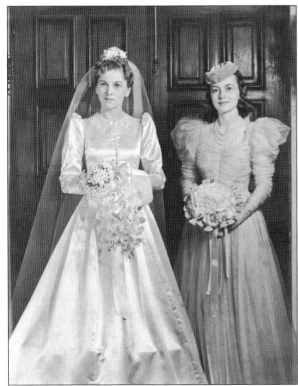

Joan Fontaine was the lovely bride of film star Brian Aherne, and her older sister Olivia De Havilland was her attendant. Both girls were Saratoga residents who attended local schools and went on to highly acclaimed Hollywood careers. Between them, they captured three Academy Awards and five other Academy nominations.

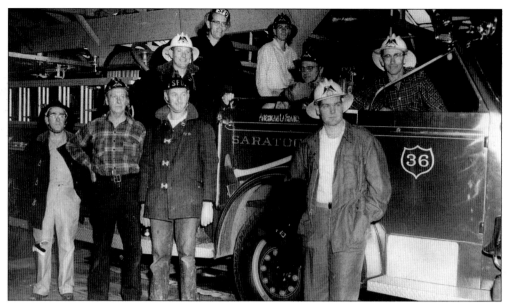

The Saratoga Volunteer Fire Department is an organization that dates to 1896 and provided critical services to the area. Today's volunteers supplement a paid fire department. For years, the Saratoga Volunteer Fire Department was one of the community's most important social groups, providing emergency training, support, and fellowship while supporting neighbors in need.

The first library in Saratoga was located in a store in the Village. In 1928, the community built the Village Library, a handsome structure designed by architect Eldridge Spencer. Saratoga is now on its fourth library building, and the Village Library houses the Book-Go-Round, operated by the Friends of the Library. The Village Library is on the National Register of Historic Places.

Two

SCHOOLS
SARATOGA'S GREATEST ATTRACTION

Saratoga is proud of its outstanding students and its school system. Beginning with a few one-room structures in the Redwood Township of the 1850s, Saratoga now has more than a dozen schools across five school districts. In addition, Saratoga also has several outstanding private schools.

The school system is the primary reason many families buy a Saratoga home. Young families struggle financially, braving the highest house prices in Santa Clara County, to give their children an exceptional education. Year after year, Saratoga schools top the lists evaluating school performance. This excellence is the result of decades of work by a dedicated community.

Publicly funded instruction in California was initiated in 1854, although there were many small "subscription schools" before that time. The earliest classes in Saratoga met in the local Temperance Hall on Oak Street beginning in 1854. This tiny structure was replaced with a two-room building in 1869. Students from the hills above Saratoga met in the little Booker School, created in 1881. Other local one-room schools included Moreland School, Lincoln School, and Austin School at Austin Corners.

At first, schools served grades one through eight. There were no kindergartens or "middle schools." Older students attended high school in Los Gatos or Campbell. After World War II, Saratoga changed dramatically as hundreds of families bought new homes. New schools were built; Fruitvale School became Redwood Middle School for grades seven through nine, and Saratoga High School opened in 1959.

Saratoga became home to a community college in the late 1970s. West Valley College, part of the West Valley–Mission College District, offers both education and training programs. The college also hosts KSAR, the local public-access television station. An emphasis on education and lifelong learning is one of the notable characteristics of the Saratoga community.

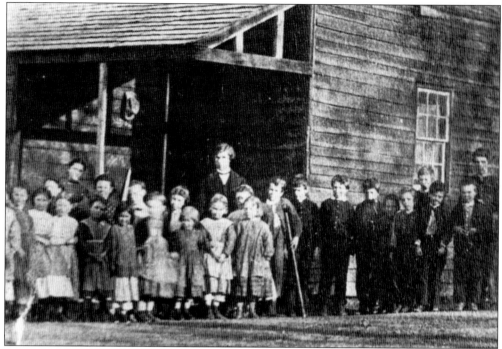

They called it the Little Brown Schoolhouse. Made of hand-hewn redwood shakes, Saratoga's first school was built by the Sons of Temperance in 1853 as the Temperance Hall. The building was located on Oak Street, on the site of today's elementary school. The site is one of the oldest known school sites in California, occupied for more than 150 years.

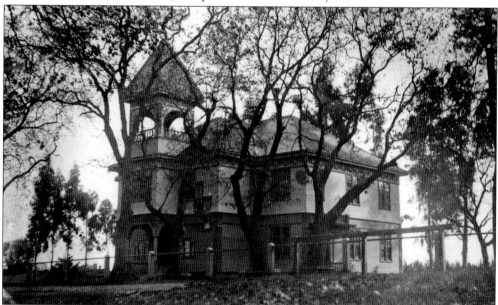

Saratoga's third school, completed in 1898 on the site of the original school, was an elegant structure with a bell tower, a fire escape, and an enlarged playground area. Robert Loosemore was the principal, serving as both teacher and principal for 25 years. The architect was Charles F. Boosinger, the contractor was W. S. Boyle, and it cost the local citizens $5,000.

Saratoga's fourth school was erected in response to concerns about earthquake and fire safety. The fourth structure on the Oak Street site was completed in 1923 and is a single-story stucco-clad structure with a tile roof in the Mission Revival style. It has been remodeled and expanded twice to meet today's needs.

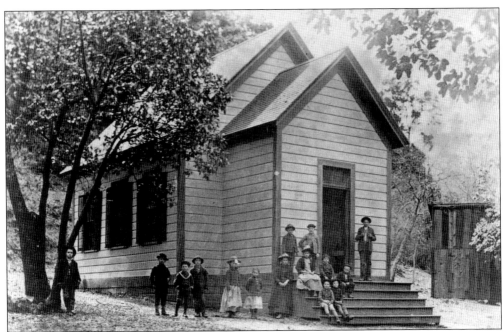

The Booker School was located in the Saratoga hills, just below the area known as Long Bridge. The hills were home to a large group of immigrants from Haute-Alps in southern France—today that area is known as Provence. Hill residents built their own school in 1881, keeping their children closer to home. The school served until 1923, when the Booker School District merged with the Saratoga School District.

The first Austin School was a one-room school with only a few students. When the road to Los Gatos was realigned, this little school was replaced with an elegant arts and crafts building designed by noted architects Wolfe and McKenzie. The new building still stands, used for many years as a kindergarten and day care center. Austin School became part of the Saratoga School District.

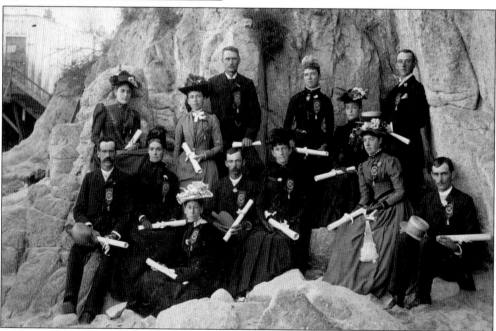

Systematic study for adults was offered through a program of the renowned Chautauqua Institute of New York. Classes were held during the summer at Pacific Grove in Monterey County, and students received certificates in literature and science. These students graduated in 1890 and include, from left to right, (first row) Mr. and Mrs. D. McPherson, Mrs. Krick, Frank Cunningham, Jennie Maclay, Martha McPherson, and Luther Cunningham; (second row) Mollie Cunningham, Lou Dale, James Fablinger, Jennie Farwell, Sadie Cunningham, and Harry Warren. James Fablinger was the son-in-law of famed abolitionist John Brown.

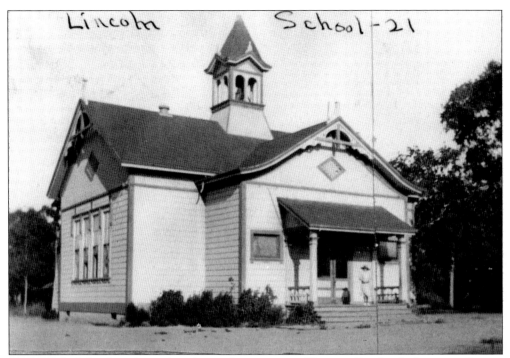

The Lincoln School was located on the northeast corner of Prospect Road and what is now known as the Saratoga-Sunnyvale Road. A new Abraham Lincoln Elementary School is now part of the Cupertino School District, not far from the location of its earlier namesake.

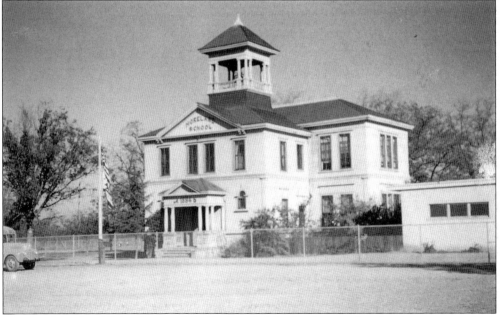

The first Moreland School, named for Zechariah Moreland, an early school trustee, was built in 1853 and was located at the northeast corner of Saratoga and Payne Avenues. This two-story building was completed in 1894 and served as the only school in the area until 1951. Now Moreland is a district with six elementary schools.

29

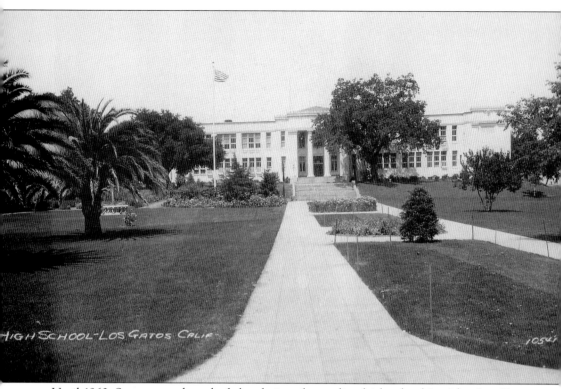

Until 1960, Saratoga students had the choice of attending high school in either Los Gatos or Campbell. Los Gatos High was the more popular choice and continues to hold a special place in the hearts of many older West Valley residents. Saratoga High School was dedicated in 1959.

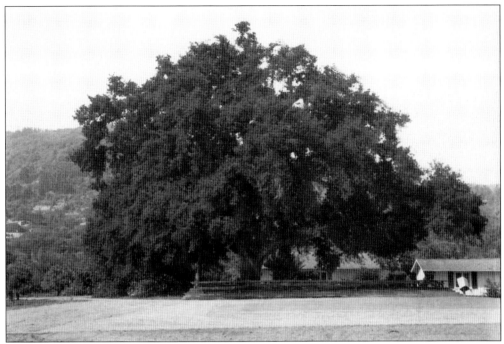

It is called the Graduation Oak because, for decades, students from the Oak Street School have been handed their diplomas under this magnificent tree. The tree is behind the school on land that was originally part of Hannah McCarthy's vineyard, then later part of the Ruddell ranch. Now the property is owned by the Saratoga Unified School District and the ranch buildings are used as the district offices.

Argonaut Elementary was one of the earliest "new" schools in the Saratoga Unified system, built in the 1950s as the enormous Argonaut subdivision was being built. Saratoga had a difficult time keeping up with the explosive growth as hundreds of new family homes were built in old orchards. State laws mandated that builders contribute money for new school construction.

Foothill School was truly in the foothills, one of the several new elementary schools built in the 1960s for the new students who were moving to the Saratoga area. Other schools built at that time in the Saratoga Unified School District include Congress Springs and Argonaut Elementary Schools. The Campbell and the Cupertino School Districts also have elementary schools that serve young Saratoga residents.

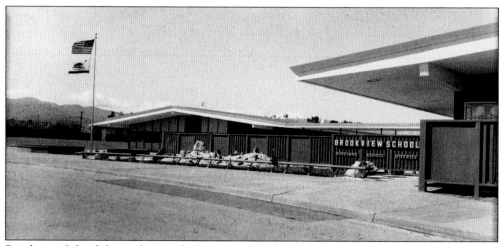

Brookview School, located on Radoyka Drive, was the pride of its new Saratoga neighborhood when it was dedicated in 1961. Designed by architect Donald Francis Haines, the structure cost $599,600 and was located in the Moreland School District. It has now been demolished.

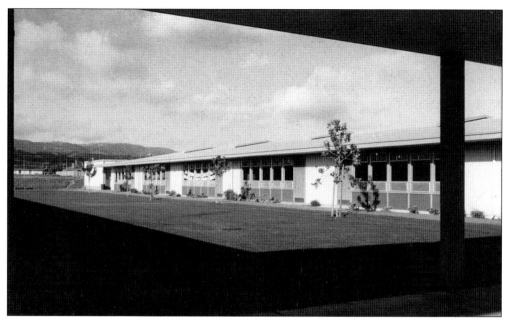

Congress Springs Elementary School was a new elementary school, designed by Saratoga architect Warren Heid, AIA, and located on Via Escuela. The structure has now been demolished, and the site was sold for additional housing. In 1958, Saratoga public elementary schools included Saratoga (Oak Street), Foothill, Fruitvale, El Quito, and Argonaut. (Photograph courtesy Warren Heid.)

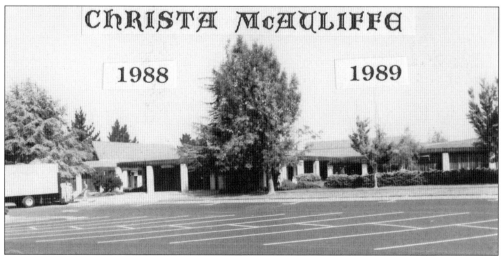

"I touch the future. I teach." These words by teacher and astronaut Christa McAuliffe have inspired countless other teachers. Christa was chosen from 11,000 applicants as the first teacher in space. She was one of seven crew members killed in the space shuttle *Challenger* disaster in 1986. At last count, there were 35 schools across America named in her honor, including this one in Saratoga. This school on Prospect Road is in the Cupertino Union School District and was originally named the Laura B. Hansen School.

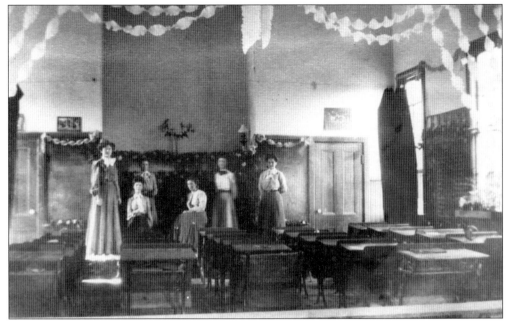

The original Austin School was a one-room school with a small enrollment. Most were students whose parents worked at the Hume Ranch, the enormous prune packing operation nearby. The school was near the Saratoga–Monte Sereno border and was replaced with a modern arts and crafts–style structure when the Saratoga–Los Gatos Road was realigned around 1910.

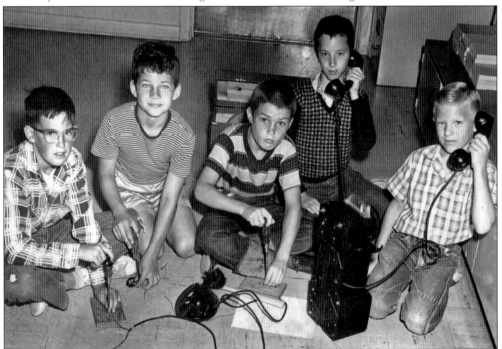

These Saratoga Elementary School students are attending an enrichment summer school with some fun projects, like building their own telephone network and experimenting with sound equipment.

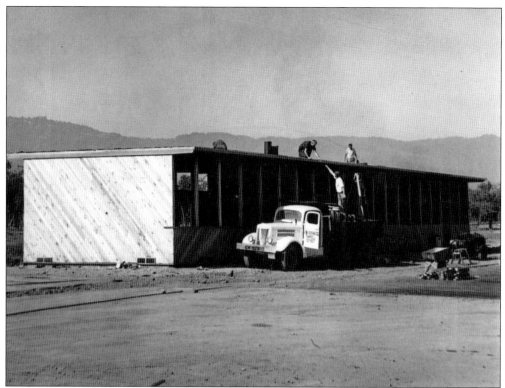

Saratoga added a middle school for grades seven through nine in 1960. With a system enrollment of 2,000 students, there was a tremendous need for new classrooms. This portable is under construction for a shop and a band rehearsal room for the newly renamed Redwood Middle School.

Redwood Middle School was created from the old Fruitvale School. With 2,000 students in the district, building several new elementary schools and creating a middle school for grades seven through nine was a high priority.

Seventh- and eighth-grade students at Saratoga School on Oak Street celebrate Mad Hat Day, sponsored by the Santa Clara YMCA Toga Teens program. The winners of this year's competition are, from left to right, (first row) Pat Werner and Donna Naletko; (second row) Steve Rowen and Alan Joyce.

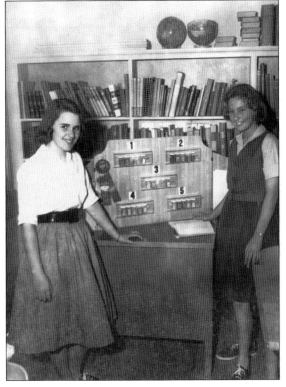

Janice Dubel and Linda Norton, eighth graders at the Oak Street School, won first prize in their division at Santa Clara County's science fair. Their project used plants as chemical indicators. Weeds and flowers were boiled and dipped in two acids and bases to observe the effects. The girls went on to compete in the Northern California Science Fair in 1961.

A unique tradition in Saratoga has been the close cooperation among the various PTAs. Here the five PTA presidents gather to discuss the upcoming Founder's Day celebration and nominate three Saratoga citizens for awards

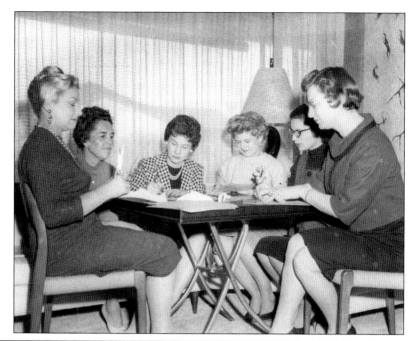

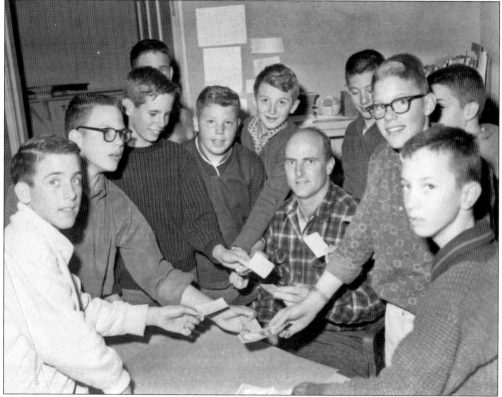

Coach Edwards, the physical education coach of the Saratoga School on Oak Street, is surrounded by students selling tickets for a father-son spaghetti dinner in 1961. The event is being held to raise money for uniforms for the school's athletic teams—the goal is $170.

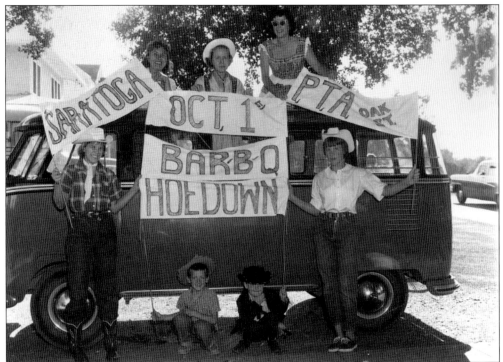

Pictured is the Saratoga School Gala Fundraising and Hoedown. Those in the top row are Mrs. H. J. Oberhaus, Mrs. David Noble, and Mrs. Robert Plevin. The cowgirls are Laurie Oberhaus and Susie Porter, and the cowpokes in front are Kent Porter and Bill Hardie. The vehicle in the rear is a Volkswagen bus, a popular alternative to a station wagon at that time.

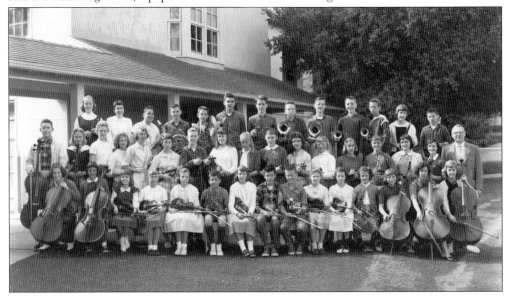

Music instruction is important to Saratoga parents, and the annual music festival and concerts presented by the elementary students was always an important occasion. The presentation was held in the Oak Street school auditorium, and the orchestra was under the direction of Thomas Bennett and Mrs. Carl Dimeff.

Music programs are expensive, and so Saratoga's music program raises funds every year with a pancake breakfast. It is held before the Rotary Art show the first Sunday in May. Phil Ward, the principal of Argonaut School, is serving up some fluffy flapjacks to Di Galli, a first-grade teacher at Argonaut.

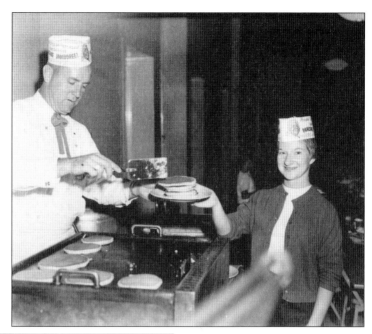

The Cooper-Garrod family has been strongly identified with education in the West Valley. Louise Garrod Cooper and her husband, George Cooper, along with Amy Coe, received honorary life memberships in the PTA for their contributions over the years. Louise Cooper's mother, Emma Garrod, was also a member of the Saratoga School Board for many years.

Saratoga finally opened a high school in 1959, a large modern structure with plenty of space and a large parking lot. Built on the Worden orchard property, schoolteacher Terry Worden was quoted in the newspaper as having very mixed feelings about selling the family orchard to the district.

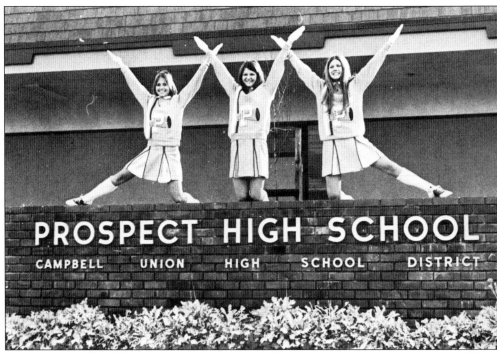

The Prospect Panthers, now part of the Campbell Union School District, are the traditional rivals of the Saratoga High School Falcons; Prospect High School serves many students from the north side of the city of Saratoga. Cheerleaders from the early years at Prospect are, from left to right, Marcy Hunt, Nancy Whitnauer, and Nancy Glass. (Photograph courtesy of Gina Campanella.)

Saratoga High School celebrated the opening of their new gymnasium with several events, including a father-son basketball game and this one, the mother-daughter basketball game. The newly fledged Saratoga Falcons would soon claim these courts as their own.

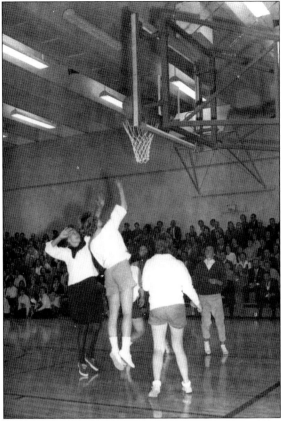

The Saratoga Falcons are ready to take on the Prospect Panthers—or just about anyone else.

Casa Bella, the Wakefield mansion, is the vantage point to see the property that will be the campus of West Valley College. The gardens of Casa Bella are in the foreground—today only a few palms remain as a reminder of the mansion's original location. The entrance to the West Valley campus is across the street.

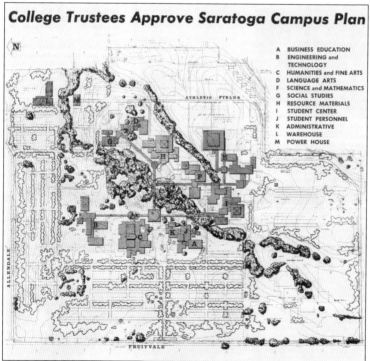

College Trustees Approve Saratoga Campus Plan

A BUSINESS EDUCATION
B ENGINEERING and
 TECHNOLOGY
C HUMANITIES and FINE ARTS
D LANGUAGE ARTS
F SCIENCE and MATHEMATICS
G SOCIAL STUDIES
H RESOURCE MATERIALS
I STUDENT CENTER
J STUDENT PERSONNEL
K ADMINISTRATIVE
L WAREHOUSE
M POWER HOUSE

The plan for the West Valley campus covered 163 acres of the orchards known locally as the Gardner-Kenyon family ranch. Daniel Gardner came to California in 1852 and settled here in 1861. The ranch was covered with apricot, prune, and peach orchards until acquisition by the West Valley College. Students attended classes in Campbell for several years while their new campus was under construction.

Three

ENTERPRISE
SMALL BUSINESSES AND LARGE HEARTS

Saratoga has had several economic lives, starting in 1847 with a gristmill and lumber mill, then as a manufacturing town with a tannery and two paper mills. By 1869, it was a summer resort for wealthy San Francisco residents escaping their foggy homes. Saratoga's climate was perfect for growing fruit, and by 1880, large-scale commercial fruit growing dominated the landscape. For more than 60 years, Saratoga was noted for its apricots and prunes. Many orchardists also processed and shipped fruit.

Saratoga residents began growing wine grapes in the 1860s. Today wine making can be considered Saratoga's only manufacturing industry. There are five major wineries that call Saratoga home, but more than 80 winemakers produce wine as a hobby. For many years, the most notable local vintner was Paul Masson, whose unique champagne was bottled in Saratoga. The Masson vineyards and bottling plants have long been closed, and the Mountain Winery, once associated with the Masson label, is now an entertainment venue.

Saratoga's "downtown" is Saratoga Village, the heart of local business for over a century. The village was once home to the post office, hotels, the library, the butcher, the baker, and the barber as well as the firehouse. There was a plumber, the Fix-It Shop, banks, and bars. Candy maker Patty Charlesworth, who hand dipped chocolates, was located in the village.

The first telephone office was here; so was city hall. The pharmacy with its soda fountain was here, along with the movie theater. More recently, the village was noted for its art galleries, antique shops, and unique dining at the Plumed Horse, Le Mouton Noir, and many others.

When Saratoga incorporated in 1956, the community made a decision to eliminate industry and restrict retail to retain the rural atmosphere of the area. Two additional shopping areas were created to serve the new subdivisions. Argonaut Shopping Center was opened in 1960, and Quito Village was created in the 1970s. The Saratoga Village Plaza opened in 1960 in response to the demand for parking next to a grocery.

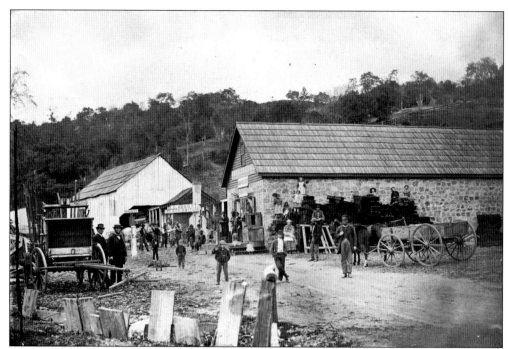

Pioneer politician Charles Maclay can claim credit for expanding the early local economy in Saratoga. After his mill burned in 1863, Maclay rebuilt and added a store, a tannery, a livery stable, and a blacksmith shop to his original milling operation. The entrance to his toll road was also located here. Today this enclave is located approximately near the entrance to Hakone.

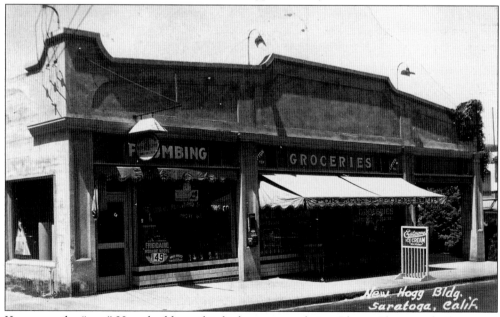

Known as the "new" Hogg building, this little structure facing Blaney Plaza was built around 1910 by Saratoga's leading physician, Dr. Robert Hogg. The good doctor was a tireless promoter, selling real estate and founding the Saratoga National Bank. For many years, this was home to Clarke and Moscarella Plumbing.

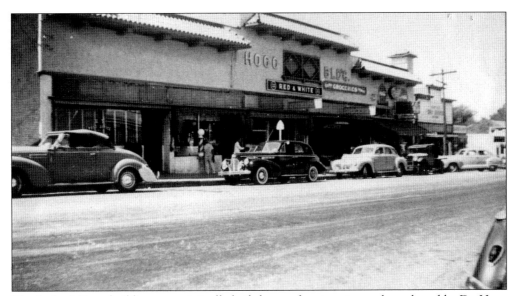

The "other" Hogg building was originally built by another investor and purchased by Dr. Hogg around 1910. It is arguably the most important business building on Big Basin Way because for years it was home to the Saratoga Pharmacy, one of the local community's business centers.

Dr. Robert L. Hogg came from Kentucky to visit his cousins, fell in love with a local girl, and devoted the rest of his life to his community. He organized the Saratoga Board of Trade, helped the Saratoga Improvement Association, invested in the Saratoga National Bank and the Saratoga Inn, and made real estate loans to many local families. His oldest daughter, Melita Hogg Oden, helped organize Saratoga's history museum.

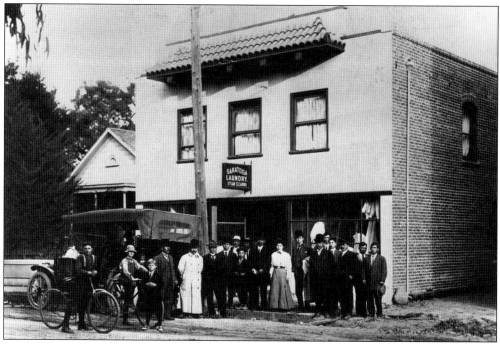

For many years, this was a Chinese laundry. When the Chinese Exclusion Acts began to have an effect around 1900, this laundry was taken over by a Japanese family, the Hatakayamas, and operated until World War II. Sarah Brown, daughter of abolitionist John Brown, taught herself Japanese in order to teach Bible classes to the laundry workers.

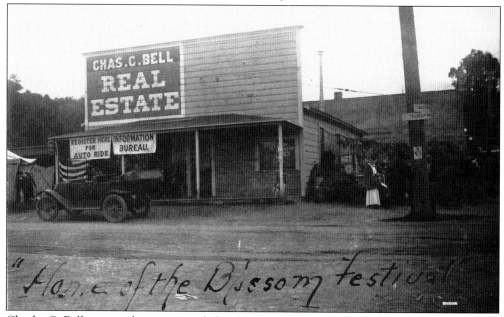

Charles C. Bell was another civic-minded real estate man with his little office right next door to Dr. Hogg. Like Dr. Hogg, he was on the first Board of Trade, promoted the Blossom Festival, and helped to bring street lighting to Big Basin Way. Saratoga has always been a profitable market for real estate salesmen who know the area.

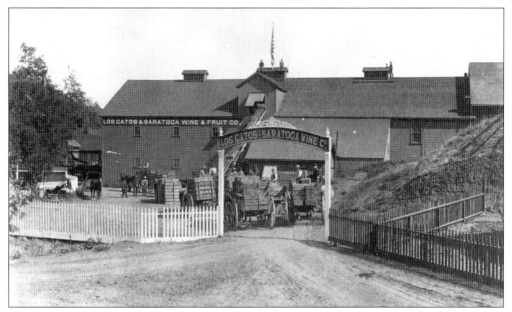

The Saratoga–Los Gatos Winery was among the largest wine operations in the West Valley. Their warehouse was located near Austin Way and was removed when the Los Gatos–Saratoga Road was realigned. Look closely to see some hardy souls who have climbed on the roof to have their picture taken.

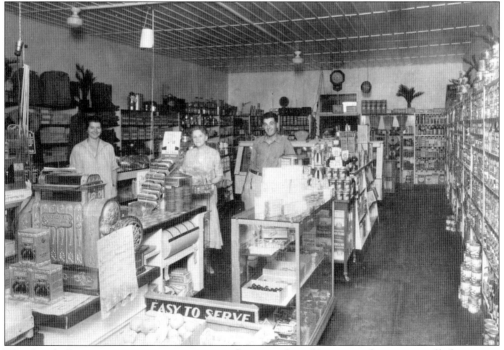

The Smith Store was a community concern for more than 50 years and was originally known as the Cloud-Smith Store. The store building is one of the few buildings in the county built with Saratoga limestone. Here Elsie Smith (center), the granddaughter of the original proprietor Samuel Cloud, helps out two customers. Laura Smith is on the left and Pete Albini is on the right.

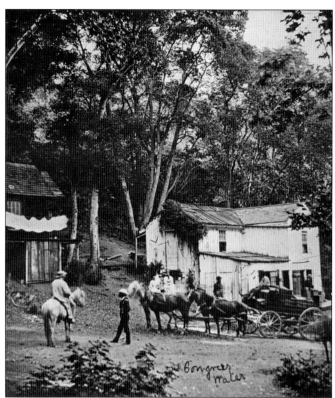

The mineral waters from Saratoga Springs were thought to be a terrific cure for a variety of stomach ailments. Spring water was bottled at this site and shipped to San Francisco in two sizes; one container was a small glass bottle, the other a large clay flask. Both are now avidly collected by bottle collectors.

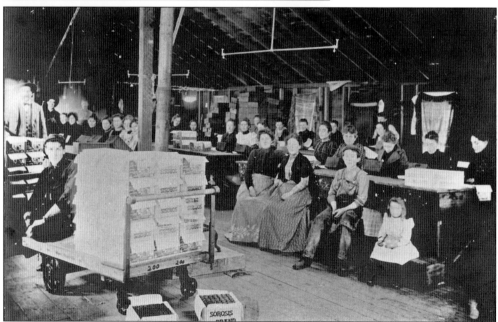

The fruit industry was so profitable that several investors came to Saratoga and built large packing plants. Borax Smith was an investor in the Sorosis Packing Company on Saratoga Avenue. The word "sorosis" means "dry." The Sorosis Company was noted for the courteous treatment of its workers.

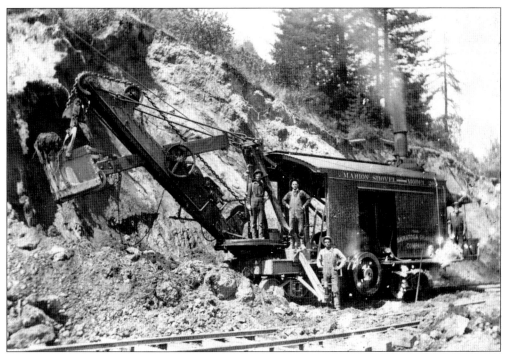

The Knapp Gravel Company, owned by Bert Knapp, was one of Saratoga's two quarries. Saratoga gravel is full of limestone and is a superior building material. When crushed, this rock is known as Saratoga slag and is one of the finest road-building materials available. It can be simply spread and rolled to provide a smooth and waterproof driving surface. Steam shovels such as this Marion Model 20 were a common vehicle used to load dump trucks.

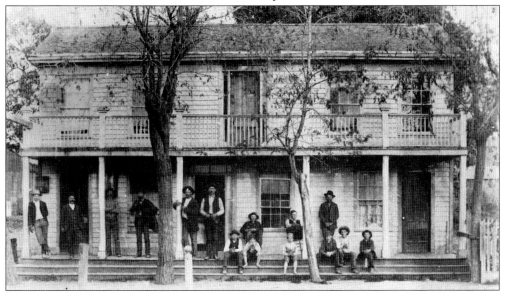

The Saratoga Hotel was located on Big Basin Way near Third Street and served the local lumbermen and other workers who came to work in the hills. It was one of several hotel establishments run by Italian-Swiss families from the Santa Cruz Mountains and served wine, a great concern to the temperance leaders in town.

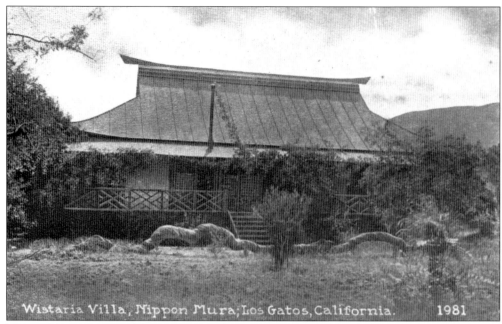

Wistaria Villa, Nippon Mura; Los Gatos, California. 1981

Nippon Mura was one of the most unusual summer lodges in the Saratoga area. Located on the Peninsular Interurban trolley line near Austin Corners, the lodge was built in 1902 by Mr. and Mrs. Theodore Morris, who had lived in Japan for many years. The resort was located on about 30 acres and attracted famous visitors from across America. During World War II, Japanese gardens were no longer popular so the resort became Hacienda Inn, an Italian restaurant and hotel.

The Saratoga Inn was a large, comfortable bungalow, built on a 6-acre plot at the corner of Saratoga Avenue and Sunnyvale Road. Around World War I, it was acquired by Elizabeth Johnston, who turned it into a summer resort. Johnston was one of many proprietors operating a boardinghouse for vacationers, but she is most memorable for her association with the Theatre of the Glade. The building was demolished around 1960.

The Saratoga Manufacturing Company lasted only for a year or two after World War II. The business was housed in the remodeled Kane's Hall, once home to the Saratoga Volunteer Fire Department. The second floor was removed, and the building was modernized. The new business made metal products such as wheelbarrows and children's wagons.

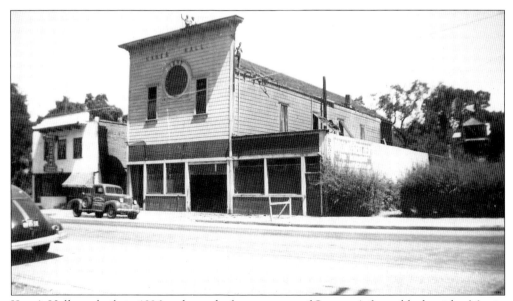

Kane's Hall was built in 1896 and was the home to one of Saratoga's finest blacksmiths. Martin Kane also served as the first fire captain for Saratoga. The town's first piece of firefighting apparatus was housed in this garage. The upstairs was called Kane's Hall and was used for lodge meetings, lectures, and dances.

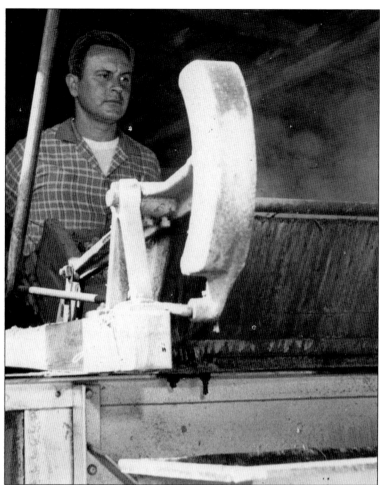

George Novakovich was one member of a large family of Saratoga orchardists. In addition to his fruit operation, George was also an early member of the Saratoga Volunteer Fire Department and is remembered for his years of service to that group. Here he is carefully watching as the prunes go through the dipper.

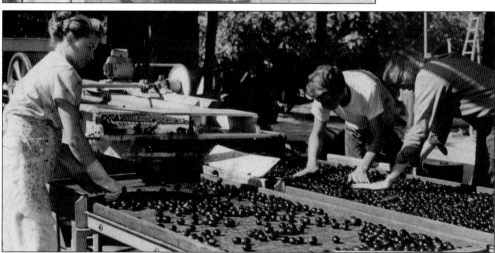

The Novakovich family has been growing, picking, and drying prunes in their Saratoga orchard for decades. Prunes are dipped into a mild lye solution and then spread on trays to dry and shrivel in the sun. Spreading the fruit and moving the trays is tough and tedious work.

Yamagami's Nursery was founded in 1948 and is one of the few remaining full-service nurseries in the Bay Area. Founded by Taro Yamagami (at right), the company expanded with a landscaping service. Yamagami was a Japanese American, raised in Salinas, and a World War II vet. The nursery building located at 1361 South DeAnza Boulevard, designed by Saratoga architect Warren Heid in the 1960s, is now a local landmark.

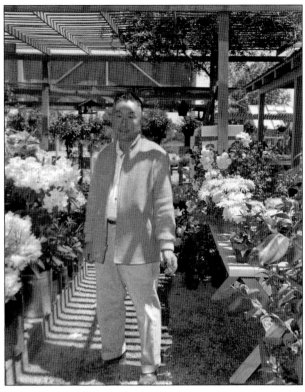

Saratoga Horticultural Research Foundation, Inc.
DEPENDABLE PLANTSCAPE SOLUTIONS

Plant Product Catalog

15185 Murphy Avenue • San Martin • California • 95046
(408) 779-3303 • FAX (408) 778-9259 • Email: saratoga@garlic.com

The cover of the Saratoga Horticultural Foundation price list features a branch of *Ginkgo biloba* Saratoga one of the many plants either patented or introduced by the foundation. Founded in 1952 and headquartered on the former Russell Ranch, Saratoga Hort promoted native California plants and drought-tolerant species. Many of their plants are named for Saratoga residents.

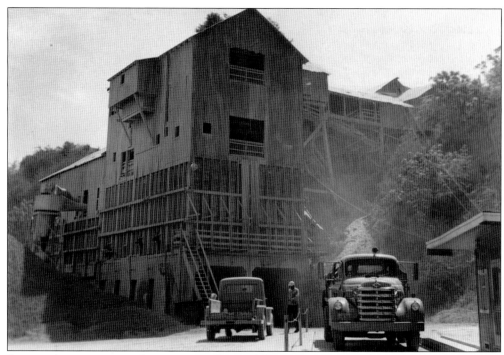

Saratoga has many natural resources, and one of the most important, discovered by the Spanish and exploited by Yankee pioneers, was the local limestone. Saratoga has two major quarries, one operated for many years by the county and one owned by the Rodoni family, contractors who were in the paving business. Both have now been closed.

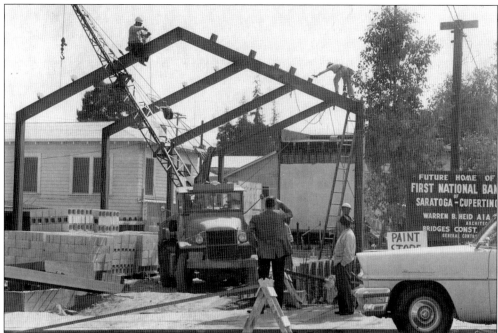

As Saratoga expanded, more banks entered the village. This bank, designed by Warren Heid, is now the Wells Fargo, located just north of the Saratoga Plaza Shopping Center.

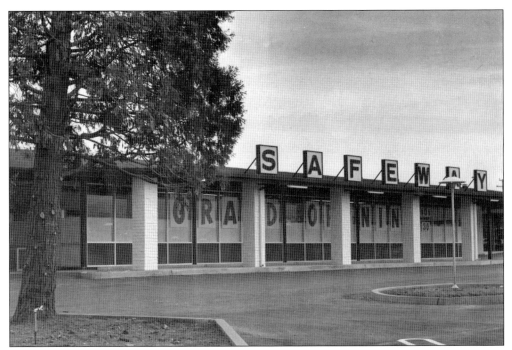

Safeway first opened in the Argonaut Shopping Center in 1960 and was a welcome addition to the community. The Argonaut subdivision, located just behind the shopping center, began developing in the mid-1950s, so local residents were delighted with the convenient shopping.

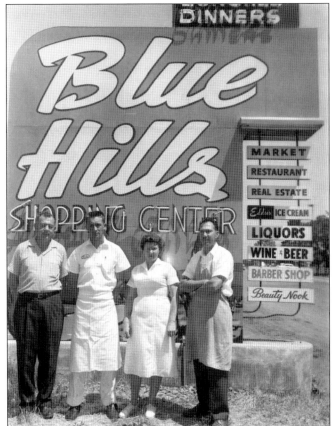

The Blue Hills Shopping Center joined the chamber of commerce, and the local representative chosen were A. Ziegler of the Bottle Shop, Richard Ericson from Cotton's Hickory Pit, Agnes Quick from the Blue Hills Beauty Nook, and William Mustain of Blue Hills Market.

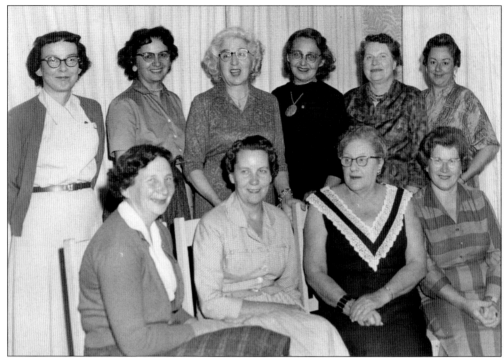

Members of the Saratoga Business and Professional Women's Club are celebrating National Business Week in October 1960. From left to right are (first row) Rose Rosenfeld, Marie DuFay, Merle Hunt, and Martha Mingo; (second row) Margaret Dolge, Bee Sanchez, Adele Bianchini, Helen Davis, Vivian Kraule, and Virginia Case. Martha Mingo ran the Saratoga Cleaners; Marie DuFay was the telephone operator. Beatrice Sanchez represents the Bank of America; Rose Rosefeld owned the Clef House, and Vivian Kraule owned a jewelry store.

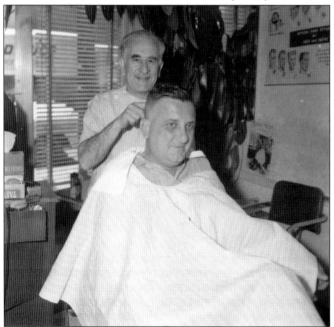

For decades, barber Pat Bucaria was a notable character in Saratoga Village. He was of diminutive stature and stood on a milk crate to cut hair. He loved to play the banjo and would often take a break from barbering a customer for a tune or two. The quality of the haircut was related to the length of his musical program. He died in 1993 but is still recalled with great fondness.

Saratoga got "fast food" when the first drive-in restaurant came to town in March 1960. Louis and Rae Ellen Gaylord opened a hamburger stand, Wimpy Burger, on Saratoga–Los Gatos Road. Louis Gaylord, a navy veteran, named his burger and his business Wimpy's to commemorate the best friend of "Popeye, the sailorman." Wimpy loved hamburgers, lots of them. A deluxe burger on a French roll was 39¢.

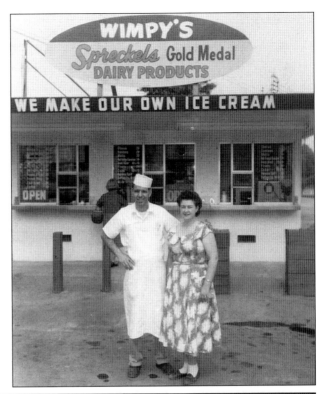

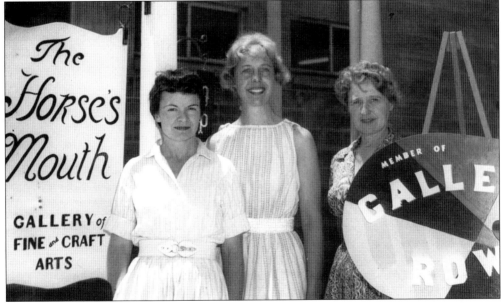

Saratoga was noted for its antique shops and art galleries that brought buyers and shoppers from all over the Bay Area. One important gallery was the Horses Mouth, located over the old Smith Store at the corner of Third Street and Big Basin Way. Mrs. Marnel Mercer, Mrs. Charles Johnston, and Mrs. Robert DeLong were all talented artists who contributed to the local arts scene. The artist in the center, also known as Lyn Johnston, created the signature icon for the Plumed Horse Restaurant.

The Plumed Horse was noted for its interior decor and for its desserts. The menu was created by Norbert Thompson and his wife, Louise Mendelsohn. The restaurant was created in 1960 on the site of their antique shop, known as Ye Olde Junk Shoppe. They planned to serve country-style meals in a casual atmosphere.

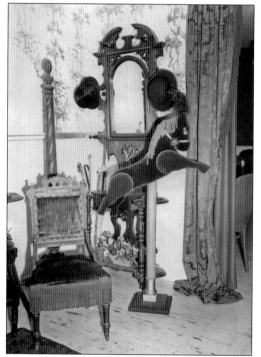

The icon for the Plumed Horse Restaurant was once a child's rocker covered in purple plush by Lyn Johnston and prominently displayed in the main dining room. The various dining rooms each had a different theme and featured antiques from the owner's former antique shop. The main dining room was covered with flocked red wallpaper, but other rooms had rustic themes. The Plumed Horse pioneered the concept of "theme dining," where the decor set the mood for the menu.

Four

FRIENDS AND NEIGHBORS
SARATOGA'S VERY SOCIAL GROUPS

What makes a community successful? Why do some communities fade and die while others prevail? What makes some communities the envy of their neighbors? One reason is clearly the character of their residents. Those with the ability to work together for the good of all make a big difference.

Saratoga is blessed with a remarkable climate and a beautiful landscape. But credit for Saratoga's success goes those early settlers who could work together. These pioneers fell into two groups; the first settlers were all affiliated with the Methodist Episcopal Church. Arriving in Santa Clara Valley in 1846, they included William Campbell and his family, his business partners William Haun and John Whisman, and a third businessman, Joseph Woodhams.

These were the hardy souls who organized the first fraternal organization in 1853, the Sons of Temperance. Together they built the first mills and related businesses in Saratoga. They built a clubhouse for their organization and allowed their new Temperance Hall to be used as Saratoga's first school.

The second group of Saratoga pioneers also had strong religious and cultural ties. They were Catholic and included Martin and Hannah McCarthy, the pioneers who first platted the town of Saratoga in 1852. The second group included Catholic immigrants from Haute-Alp in France. They settled in the Santa Cruz Mountains behind Saratoga, grew grapes and fruit, made wine, and manufactured charcoal. These families include names such as Baille and Boisseranc, Rodoni and Rispaud, Lotti and Ladarres. Several of these families later operated hotels in Saratoga Village.

In addition to the strong church groups, another organization critical to forming Saratoga's community spirit was the Saratoga Volunteer Fire Department. For over 100 years, men from both sides of the temperance question, and from all economic and social groups, came together to work for their community.

One other group with strong community ties over the decades is the board and PTAs of the Saratoga schools. Since their school district was formed in the 1854, Saratoga residents have worked together for their children's education. All have played a strong role in creating a vital Saratoga.

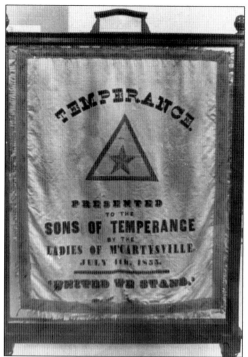

The Temperance Banner is a symbol of the ideals of Saratoga's early pioneers. It is a rare and beautiful artifact, two layers of silk painted in 1853, made to hang in the new Temperance Hall. Before the hall was built, Methodists gathered under an enormous oak tree near Campbell's Creek to hold their temperance meetings.

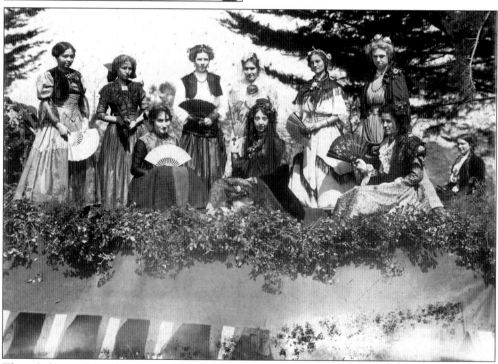

These ladies in Spanish costumes are participating in the annual Blossom Festival, but they are all members of a group with a higher purpose. They belong to the Priscilla's, a group named for a popular needlework magazine of the day. They gather regularly to socialize, show off their latest projects, and to sew for the needy. Florence Cunningham is seated in the center.

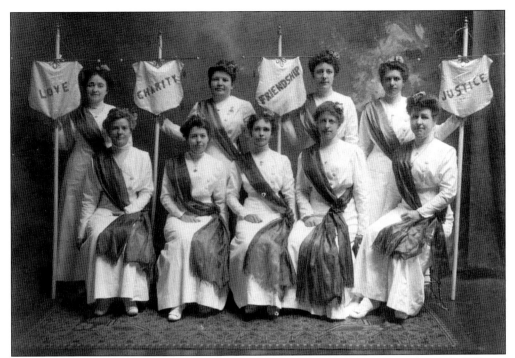

Dressed in summer finery, these Saratoga matrons have formed the Fraternal Aid Drill Team, perhaps to support the volunteer fire department. All of the ladies shown are wives of fire volunteers, but this was a time when nearly everybody in town was a member of the department. From left to right are (first row) Carrie Seagraves, Delia Rice, Sadie Oldham, Anna K. Renn, and Mary Kane; (second row) Hattie Tomlinson, Stella Rodoni, Mae Worden, and Esther Young.

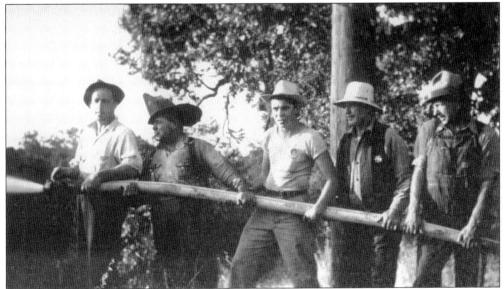

Timed hose exercises were part of the Saturday drills for members of the Saratoga Volunteer Fire Department. Hanging on to the hose from left to right are Everett Priest, Willis Rodoni, Neil Rodoni (Willis's son), Pete Albini, and Jack Clarke. Willis is in charge with the whistle and the old helmet.

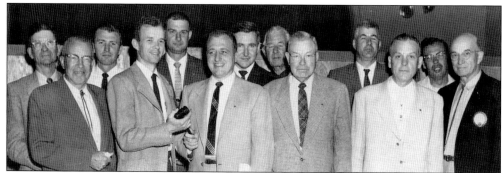

An influx of young families meant local civic organization had enthusiastic and energetic young members. In this picture, the Saratoga Lions Club, a civic-minded club that focuses on helping the blind and working to cure preventable blindness, has just elected Willys Peck as their president. Willys is being presented the association gavel.

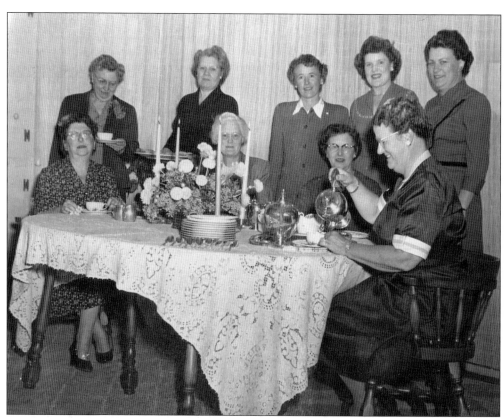

Leaders of the Women's Auxiliary of the Federated Church are getting together for tea and to plan their upcoming programs. They are, in no particular order, (seated) Mrs. Raymond Pearson, Mrs. Edwin Cox, and Mrs. Charles W. Stewart, doing the honors with the teapot; (standing) Mrs. Charles N. Cunningham, Mrs. Jack Olney Jr., Mrs. Owen Winston, and three unidentified.

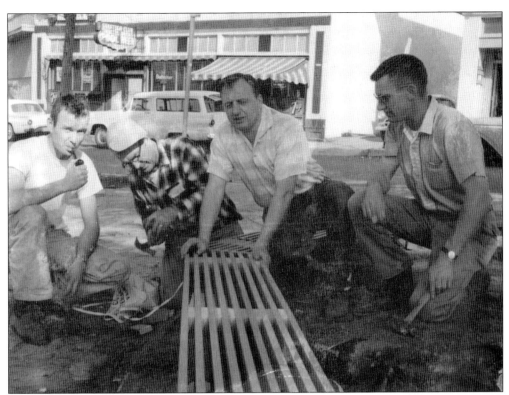

The Lions Club installed 36 feet of redwood benches in Blaney Plaza in the summer of 1960. In a small town like Saratoga with no city maintenance staff, it takes community effort to maintain the public gardens. From left to right are Willys Peck, Clarence Neale, Warren Sturla, and Jim Winram in February 1960.

The fifth anniversary of the Saratoga Rotary club was celebrated with a big cake and a lot of congratulations. Participating in this happy event are the organization's presidents, from left to right, Warren Heid (then the president), George Kocher, Richard Rhodes, Frank Daves, Ron Avery, and Vladimer F. Fabris.

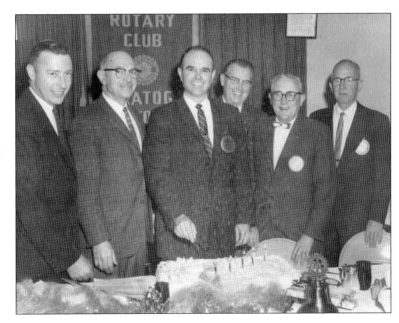

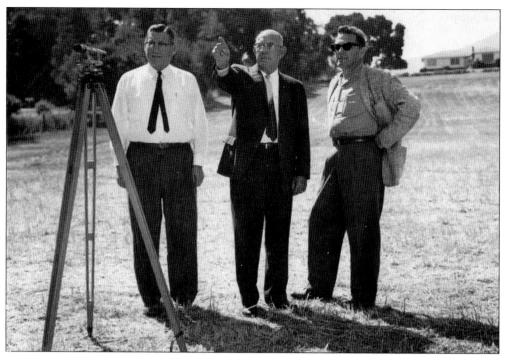

The International Order of Odd Fellows (IOOF), a fraternal organization, has called Saratoga home since 1912. They acquired 82 acres on Fruitvale Avenue and built a magnificent retirement home for their members, landscaped with extensive gardens. In recent years, they have expanded the housing options at their site, adding apartments for retired couple and housing for members in need of assisted living. They are planning their expansion. Clark Arneal of IOOF (left) and contractor Bud Smith (right) talk with Charles Henderson, IOOF California secretary.

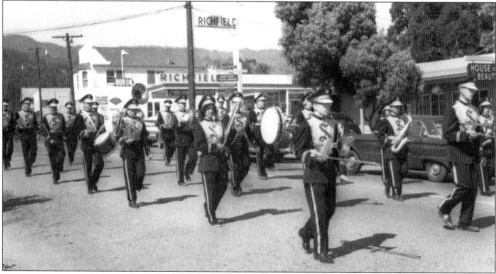

Saratoga High School had only been opened for a year or two, but their new marching band was already the pride of the community. Here they participate in opening day ceremonies of the girls' softball league. Other groups participating in the parade included local Scout troops and the Saratoga Volunteer Fire Department.

The Saratoga Filly's, a softball league for girls, marches proudly in a parade to celebrate the opening of their season. The Angels are happy to be beginning a new season, and they are followed by the other five teams in the league. Hon. Richard Rhodes tossed out the first pitch at the opening game.

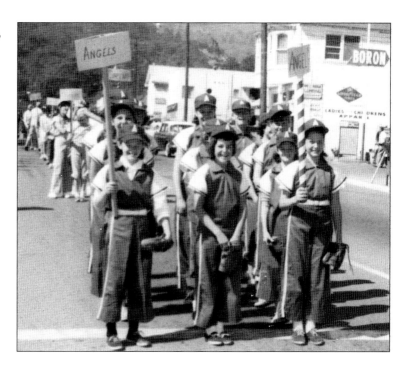

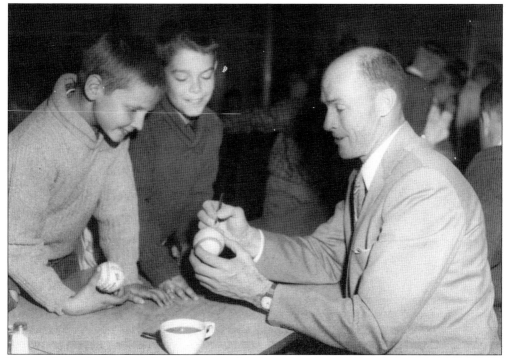

It was a big night for Little League sons and dads as they attended a dinner and raffle to raise money to build a new diamond at Foothill School. These enthusiastic young collectors are having a ball signed by Ed Sobeyak, the baseball coach of San Jose State.

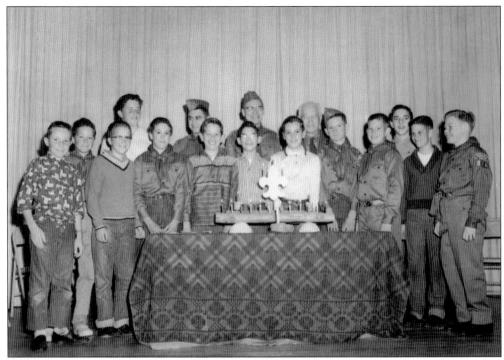

The members and leaders of Boy Scout Troop No. 324 are honored at this gathering. The troop was sponsored by the Quito School PTA, which had 15 Scouts. Shown here are (first row) Butch Gunison, James Wallace, Mike Wallace, David Carrara, Bobby Picard, Larry Chaidez, Rick Picard, David Deslile, Stephen Jensen, Gary Myrick, and Brandt Woodward; (second row) Ted Campbell, John Eshbaugh (Scoutmaster), Karl Mann (assistant Scoutmaster), and John Wiley.

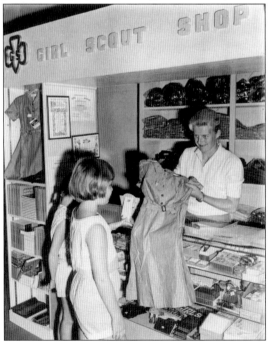

Scouting was an extremely popular group activity for girls as well as boys. Whitlow's department store began carrying Girl Scout uniforms and Scouting accessories. Whitlow's was located on Big Basin Way and was the town's only department store, selling all the basics. Mary Madden of Troop 623 is being helped by Bobbi Wickland.

Top students in each class of the new Saratoga High School were honored by the Saratoga Rotary. Sophomore Kathy Crane, junior Wayne Brazil, and freshman Mike Huxtable are on the left. Warren Heid (second row, center), president of the Rotary was on hand as well as Diane Arakelian (first row, right), the program soloist, and her accompanist Dick Moyer (second row, right).

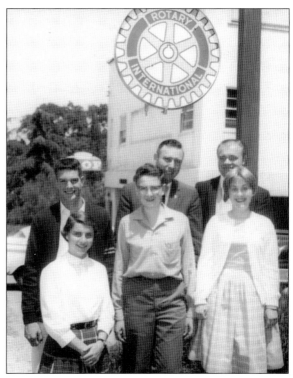

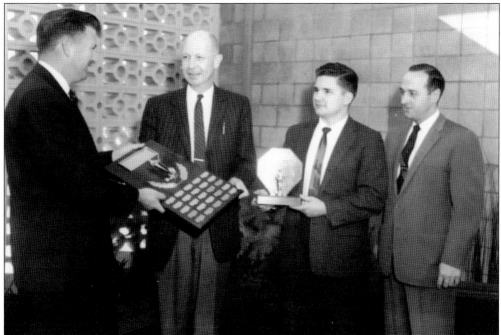

The Saratoga Optimists hold an annual contest in public speaking and are presenting a 25-year plaque to Saratoga High School with names of winners. Stu Smith is on the left, presenting the plaque to Vernon Trimble, principal of the high school. Hugh Roberts holds a trophy, and Joe Assenza, chairman of the oratorical contest, is on the far right.

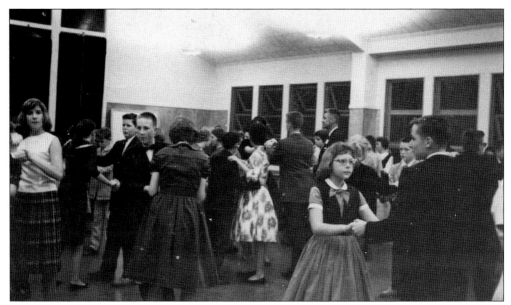

The Central Valley Branch of the YMCA sponsored programs and dances for Saratoga's young residents through a program known as Toga Teens. This dance was being held in the cafeteria of the Saratoga School on Oak Street. Other activities included hayrides, swimming, skating parties, and snow trips.

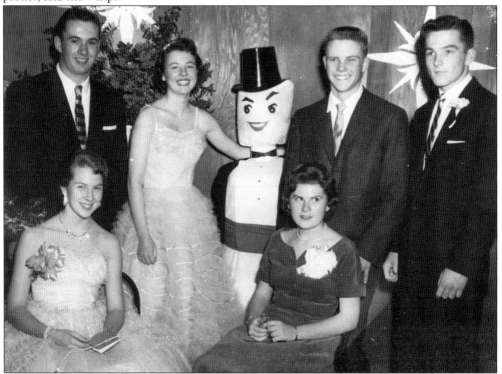

The Foothill Club is an elegant Saratoga venue for dances and parties. This party was held in December, so the figure in the middle must be a snowman, but he is not looking very "frosty." These young people are wearing semi-formal attire for their event, so it must be a special party.

The Saratoga Lanes hosted a local bowling league where all of the teams were named for insects. There were the Crickets, Mosquitoes, Bees, Wasps, Termites, and so on, 14 varieties total. The league was known as the Bug-E-Bowlers, and the officers were, from left to right, Stu Howell, Rene Bourdet, and Bev Locicero.

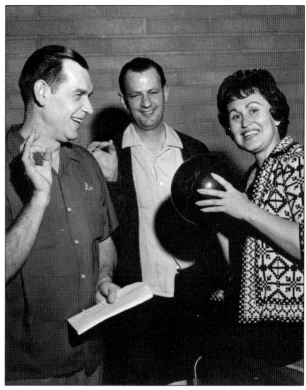

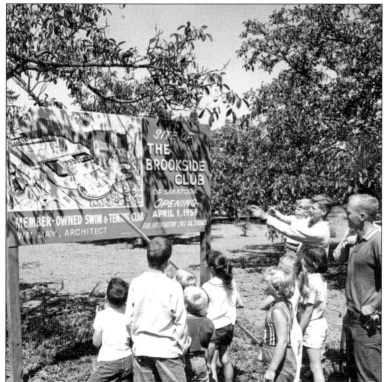

The Brookside Club was under construction in 1961, located in an orchard off of Cox Avenue. The sign lists the designer as Cliff May, noted for popularizing the California ranch-style home. Membership is limited to 250 families, and the activities feature swimming and tennis.

The Saratoga Country Club is just a gleam in the eye of this young golfer, waiting for the new course to open. Construction is beginning on the nine-hole course and pro shop located on 52 acres on Bubb Road. The club has 331 members but hopes to get 450 subscribers in order to build a swimming pool, tennis courts, and a clubhouse.

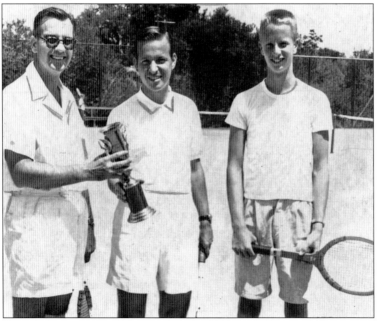

The Saratoga Tennis Club was opened and organized in 1958 for neighbors who like getting together for a few quick sets. Located in a quiet area behind the Saratoga Grammar School, the club is one of Saratoga's best-kept secrets. Frank Hawkes is shown here with his son and his son's friend.

The American Association of
University Women (AAUW)
presents a special award to
Grace Richards. Richards
was instrumental in bringing
Julia Morgan to design the
Foothill Club as well as
being a founding member of
the local AAUW chapter.
An AAUW scholarship
is named for Richards,
here being honored with a
corsage by Ruth Beckwith.

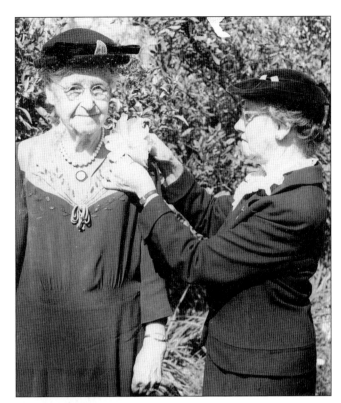

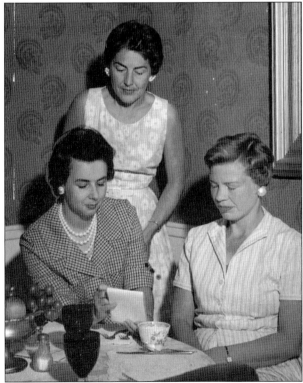

Members of the Eastfield League,
later known as Eastfield-Ming
Quong, raise money to help
children with emotional problems.
The group organized the Butter
Paddle, a Saratoga gift shop that
is a local institution. Lunching
at the Plumed Horse to plan this
year's activities are, from left
to right, Mrs. Sydney Toscato,
Mrs. John Podd (standing),
and Mrs. John Hughes.

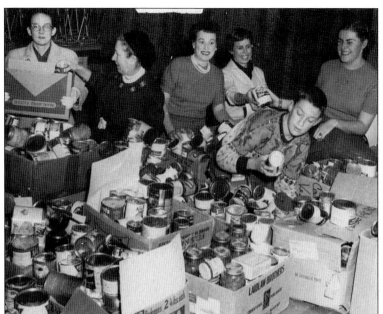

The Foothill Club has many programs and activities to help the community. One of their projects prepares Christmas baskets, and these enthusiastic members have recruited a young helper to give them a hand organizing the canned goods. This particular effort took place in 1957.

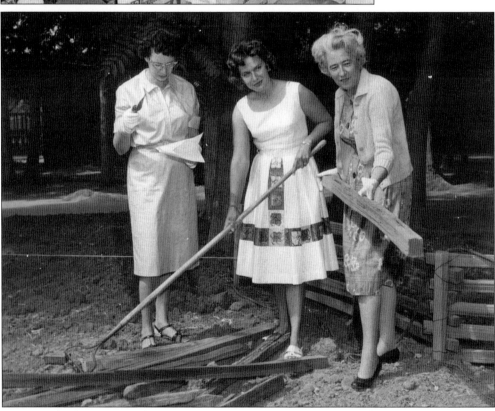

Preparing for their entry in the annual county fair, Saratoga Garden Club members are preparing to work with 11 other local garden groups on a major entry. Shown are Mrs. Paul Otten (the fair chairperson holding the rake), Mrs. Lawrence Houk (chairman of the Saratoga Seedlings garden group), and Mrs. Charles White (director of the project committee).

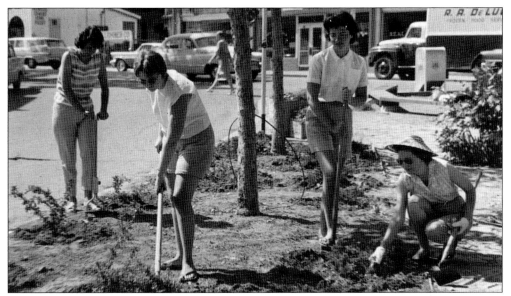

There have always been gardeners in the village, residents who are willing to spend a little time to make the community a pleasant place for others. Sprucing up Saratoga Plaza, sometimes known as Blaney Plaza, are four of Saratoga's young matrons from a group known as the Saratoga Seedlings. From left to right, they are Mrs. Frank Dawson, Mrs. James Day, Mrs. Howard Weatherholt, and Mrs. Paul Bowlin.

Meeting the neighbors in Saratoga is the friendly thing to do. Four newcomers to Lanark Lane met their new neighbors at a brunch in the home of hostess Ruth Morrison. The newcomers were Hazel Ely, Dorothy Robinson, Doris Pfeiffer, and Betty Harrison. Welcoming them were Dorothy Moss, Eileen Blumenthau, Lucille Greer, Lorretta McFarlin, Marian Cullen, Mary Zeigler, Barbara Ray, Evelyn Voges, Lois Bailey, Polly Baskin, Eunice Gipe, Ann Tophorn, Katherine Leitz, Toni Parks, Ella James, Esther Dickler, and Jean Woodward.

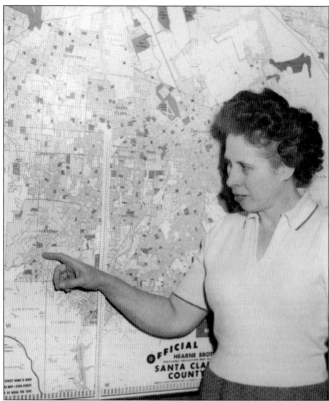

Margaret C. Whalen, the wife of the Saratoga postmaster, was a community leader and member of several civic organizations. She was the chair of the local March of Dimes campaign, a fund-raising effort held every year to raise money for the victims of infantile paralysis and for finding a cure for this terrible disease. Thanks to the efforts of many donors and the discovery of a vaccine, polio is no longer a scourge.

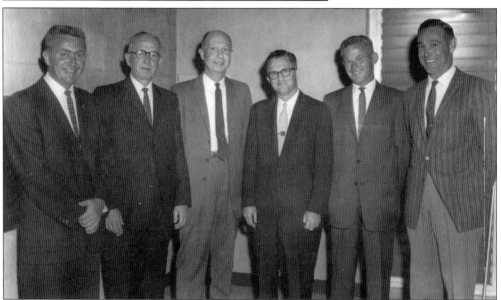

Although it is a small town, Saratoga is known for its community service programs. Leaders of four local service clubs were honored at a local dinner and musical program held at the high school in the spring of 1961. The leaders are, from left to right, Ed Fox (Kiwanis), Van Fabris (Rotary), Dr. Vernon Trimble (Saratoga High School superintendent), James Green (Civitan), and Robert Grand (Lions Club). The sixth person is unidentified.

Five

CIVIC GROWTH
MUNICIPAL SERVICES FOR A SMALL TOWN

The Saratoga community grew up around an ancient path to the Pacific Ocean. First used by the Muwekma Ohlones, the route was shown to the Spanish missionaries. The modern route travels between the Santa Clara Mission and is now known as Saratoga Avenue, Big Basin Way, and State Highway 9.

Modern Saratoga was originally three separate settlements with three different names. The oldest was Campbell's Mill, located in 1847 near Saratoga Springs or Long Bridge. The second community was named McCarthysville, platted in 1852 by Martin and Hannah McCarthy. Building lots in Saratoga Village still reflect the original McCarthy plat. The third community was established between the first two and was called Maclaytown or Bank Mills, established around 1863. Few citizens liked the name, and the name Saratoga was selected in 1865 after a popular vote at a patriotic celebration.

Saratoga was a very small but thriving community with lumbering, paper mills, a resort, and several stores. Civic life was managed by tiny group of local merchants. They formed an improvement association that became the chamber of commerce in 1926. This group changed the name of the main road from Lumber Street to Big Basin Way in 1927. Twelve merchants voted; nine supported the name of Big Basin Way, two wanted the name Lumber Street, and one wanted Saratoga Avenue.

Saratoga was a quiet place until 1900, when two events brought hundreds of visitors to the area. The first was the creation of the enormously popular Blossom Festival in 1900, followed by the opening of the Peninsular Interurban in 1903, bringing a trolley line to Saratoga. Several residential subdivisions were created within walking distance of the new interurban station.

Saratoga finally became an incorporated city in 1956 in order to keep from being swallowed up in San Jose annexations. At that time, the community decided to retain its rural nature and banned manufacturing from the area. Saratoga has few sidewalks, installs streetlights only for safety, and works to retain its bucolic atmosphere. Police and fire protection were originally provided by the county sheriff and the Saratoga Volunteer Fire Department.

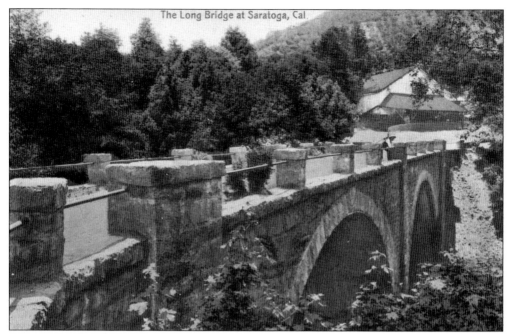

In 1893, state law mandated that county surveyors design local bridges. John G. McMillan, Santa Clara County surveyor from 1890 to 1914, built this structure at Long Bridge in 1902, the lovely Saratoga Creek Bridge. McMillan used local stone in combination with concrete to create a structure that reflects the local environment. The Saratoga Creek Bridge is one of the oldest concrete bridges in California and for many years was one of the longest, with a span of 136 feet.

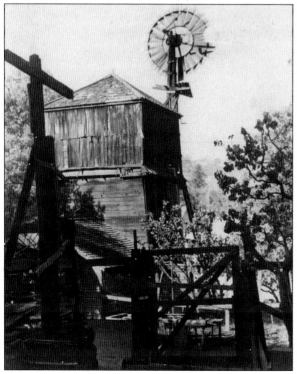

The Saratoga windmill, located on Third Street near Big Basin Way, was a village landmark until the 1970s. Water is plentiful in Saratoga, and village residents relied on huge redwood tanks such as this one to supply the water for their cooking and personal needs. The pump was driven by a windmill, and water was stored in a large redwood tank. Most houses had a tank tower in the backyard, and it is possible this particular tank supplied water for several village families.

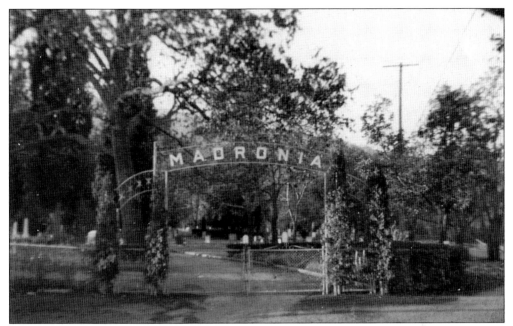

Madronia Cemetery is one of the most picturesque spots in Saratoga. It was established in the 1850s when Jose Ramon Arguello donated land for a burial site. The Madronia Cemetery Association was organized in 1863 to care for the cemetery, although some accounts say the first burial was in 1854. Along with the Saratoga School District, the cemetery association is one of the Saratoga area's oldest civic organizations.

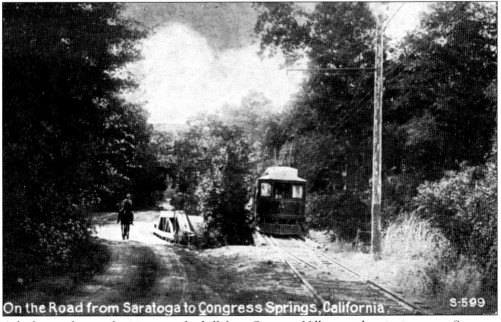

On the Road from Saratoga to Congress Springs, California S-599

A little spur line took visitors up the hill from Saratoga Village to the picnic area at Saratoga Springs. This view from a postcard shows the single track before 1910, when the area was still quite rural. Saratoga Springs is still open during the summer and a popular destination for camping and picnics.

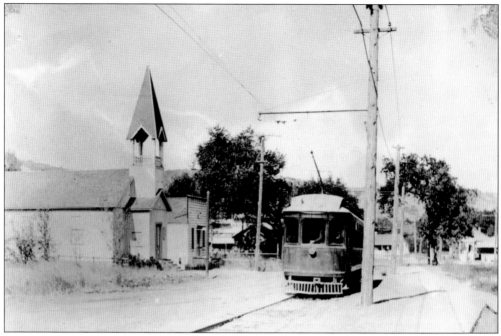

From 1903 to 1933, there was a trolley that ran through village known as the Interurban. It was replaced with bus service, first the Peerless Stages, now the county's transit line. The Saratoga Methodist Episcopal church was built in 1896, the belfry added in 1903, and was later sold as an artist studio in 1924.

The town of Los Gatos, four miles from Saratoga, got a rail line in 1878. The South Pacific Coast Railway, a narrow-gauge line, opened the West Valley for fruit production, allowing Saratoga orchardists and fruit dryers to ship their products into San Jose or all the way to the international ports via Alameda Island in Alameda County.

This famous trestle was known as the Bonnie Brae trestle and was located near Austin Corners on the route between Los Gatos and Saratoga. The trestle was removed when the road was realigned. This location was a favorite with photographers, and there are many images of the Peninsular Interurban on this rather exciting section of right-of-way.

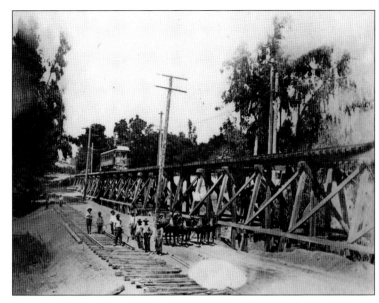

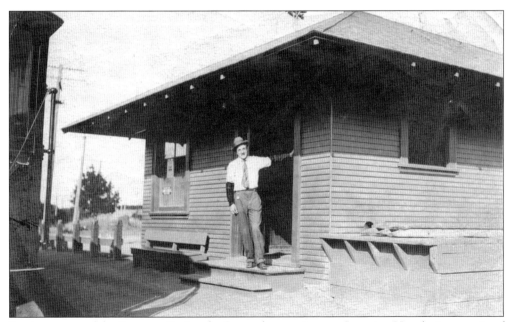

Stationmaster of the Saratoga Peninsular Interurban station was Lorraine Hanchett, a cousin of Lewis Hanchett, the man who actually built the trolley line. One can assume Lorraine got the job because he knew the boss. This is Saratoga's first station, a substantial structure located at the corner of Big Basin Way and Sunnyvale Road. Hanchett lived nearby on Oak Street. The later station building was much more modest.

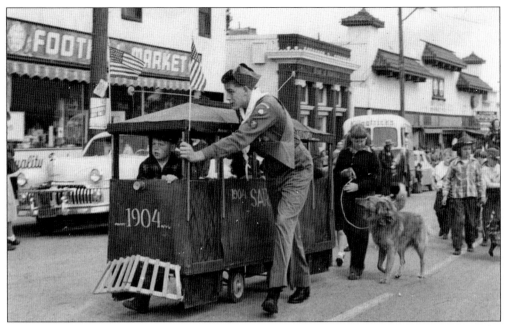

Jack Cox Jr. is the motorman driving this replica of the Peninsular Interurban, Saratoga's trolley from the early days. The conductor is Robbie Kilbourne, and they are just a few of the 350 youthful participants in a colorful parade to celebrate the 100th anniversary of the Saratoga community in 1950.

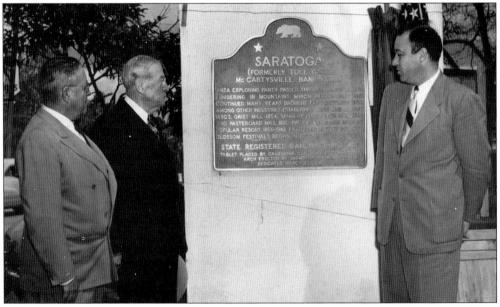

The California centennial celebration brought Oakland newspaper publisher Joseph Knowland to Saratoga to present the town with a commemorative plaque naming the entire town of Saratoga as State Landmark No. 435. Joseph Knowland was the state chairman for the California centennial event, held in 1950. Paul Crawford from the Saratoga Chamber of Commerce is on the far left with Joseph Knowland. On the right is Robert Kirkwood, an assemblyman and later the state controller; he was the speaker at the dedication.

Before Saratoga was incorporated, the nonprofit Foothill Club was the only local group with legal standing. So when Blaney Plaza was created, the deed was entrusted to the Foothill Club because of its corporate standing. Dr. Burton Brazil, Saratoga's mayor, took the title to Blaney Plaza in 1957. Transferring the deed are Mrs. Ephraim Dyer Jr. (left), the Foothill Club president, and Mrs. Virgil Campbell (right), the secretary.

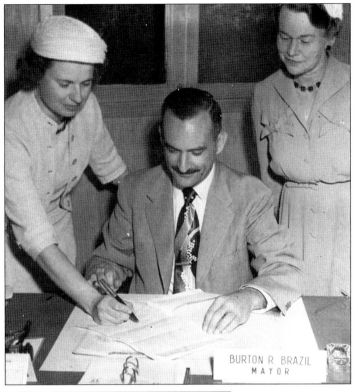

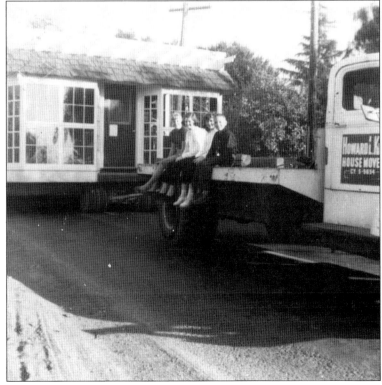

Saratoga's first city hall was packed up and moved from its original location on Saratoga–Los Gatos Road in 1960. The tiny structure was relocated to the new civic center property on Fruitvale Avenue and served the city and its five-person staff until a new structure could be completed.

81

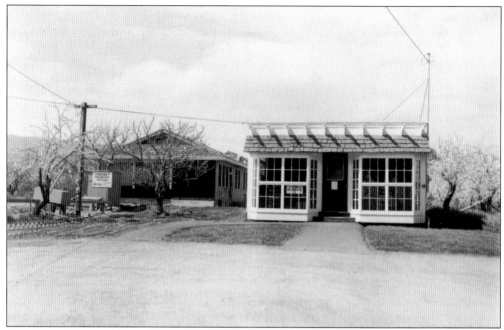

The City of Saratoga was incorporated in 1956 with Dr. Burton Brazil as its first mayor. The first city hall was a little two-room building located adjacent to the Professional Building on Saratoga–Los Gatos Road. This tiny structure was moved to this new site on Fruitvale and served as the office while a new city hall was under construction.

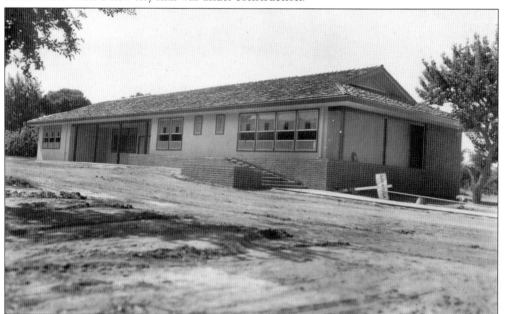

The new Saratoga City Hall was under construction in 1960 and not a moment too soon. The newly incorporated town was nearly five years old, and their old office, sometimes called the Doll House, was terribly cramped. The new building cost $43,175, and the construction contract was awarded to Howard Haldeman. The building opened six weeks ahead of schedule and was one of three buildings planned at the site.

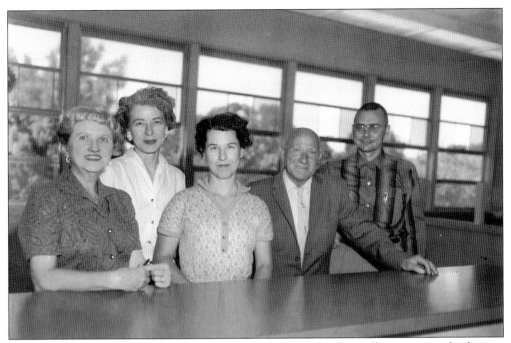

City staff takes over their new space. From left to right are Helen Conwell, secretary to the director of public works; Toni Parks; Dean Rolhishburger; Gordon Howe, city administrator; and J. Huff, the city engineer.

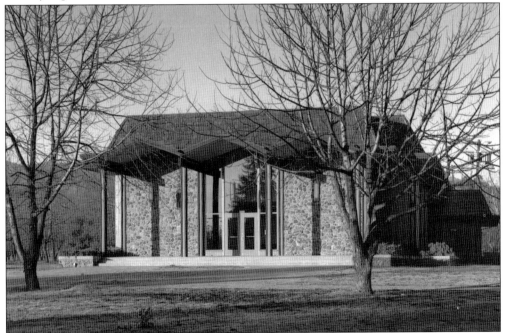

In 1962, the city hired architect Warren Heid, AIA, to design a council chamber-auditorium adjacent to the first building, leaving room for future expansion. The auditorium seats approximately 250 people. The exterior features local materials including redwood shakes and siding and native stone from a local quarry. (Photograph courtesy of Warren Heid.)

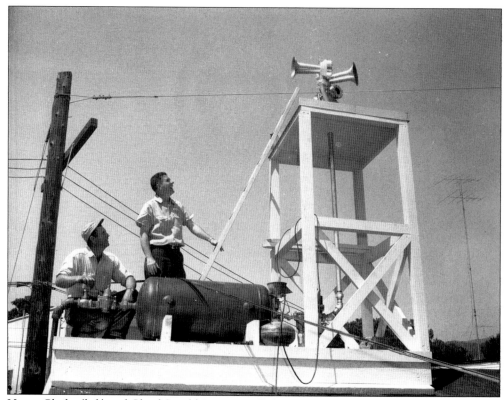

Henry Clarke (left) and Chief Gerald Renn install three horns—six, eight, and 10 inches in size and costing $3,500—on top of the Saratoga firehouse. For years, the Sunday morning horn tests disturbed attendees at the nearby Federated Church.

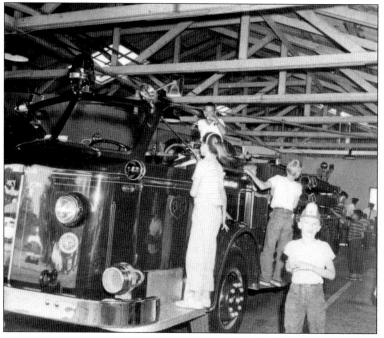

Fire prevention week is the time when everybody gets to climb on the engines. The youngsters are taking full advantage of the opportunity, climbing on the Saratoga Volunteer Fire Department's 1955 American LaFrance engine. For more than 75 years, the fire station was a converted garage, with its old, exposed rafters showing here.

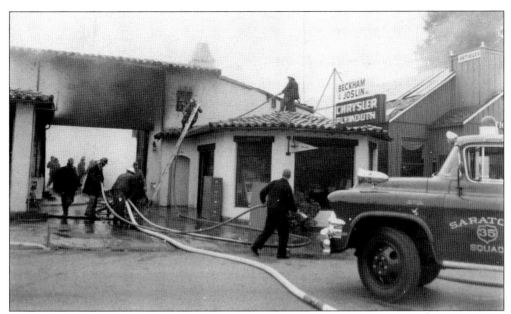

Gas dripping from a new car exploded into flames when a mechanic dropped the lamp he was using to look for the source of the leak. Saratoga's Volunteer Fire Department was located just across the street and was able to contain the blaze at the Beckham-Joslin garage very quickly using a new piece of equipment they had just purchased.

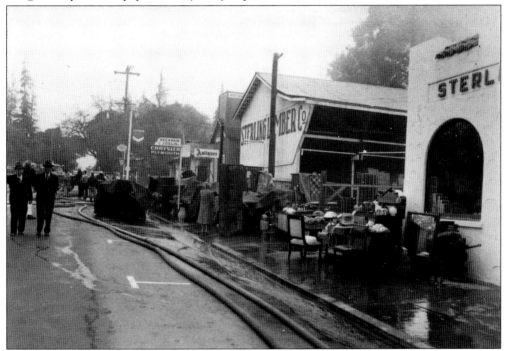

The Corinthian Antiques store was originally located in the old Methodist church next to the Beckham-Joslin Chrysler dealership. Proprietors Bob Kanglsi and Vern Halcamp later moved their business a few doors down the street. They sometimes joked that they had more damage to their merchandise from well-meaning movers than from the fire itself.

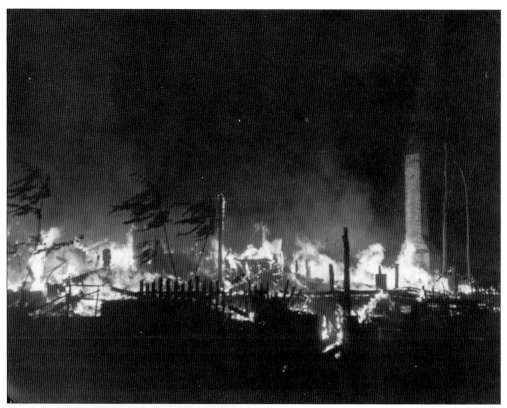

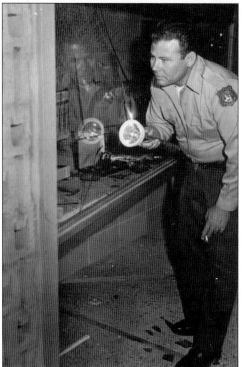

The destruction of the Saratoga Springs Store at Long Bridge in June 1960 was a devastating blow to the community. This historic structure was reportedly an 1848 bunkhouse for lumber workers a century ago. The new owners of the store, Mr. and Mrs. James Fisher, had just restocked and all the merchandise was a total loss. Firefighters were hampered by the weather in this blaze, recalled as one of the community's worst fires.

The City of Saratoga chose not to hire a police force, so this robbery at Kraule's Jewelry Store, located on Big Basin Way, was investigated by the Santa Clara County Sheriff's Department. The two thieves broke the window with a hammer late at night but were observed when they jumped in the car, driven by an accomplice.

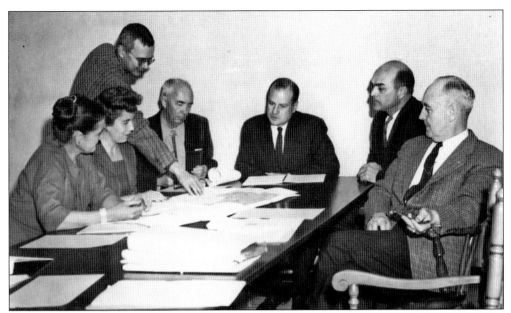

Widening parts of State Highway 9 to four lanes was a very controversial proposal. Saratoga mayor Dr. Burton Brazil appointed a fact-finding committee to prepare a recommendation. The committee included two councilmen with opposing views, two planners with opposing views, and three citizens. Pictured from left to right are Louise Cooper, Mrs. Edward Crecelius, J. R. Huff, Richard Bennett, J. S. Langwell, Dr. Clemmer Peck, and Frederick Crisp.

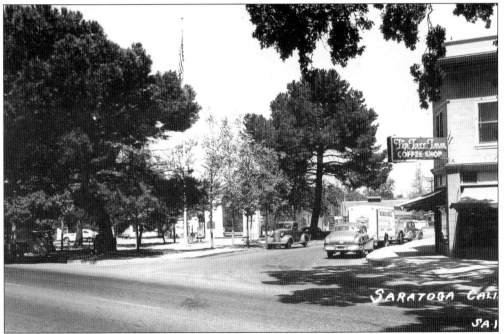

The Fir Tree Inn was located on the corner of Saratoga–Los Gatos Road and just across from Blaney Plaza. It was an important building to the community and was used as the station for the Peerless Stage, the bus service that replaced the interurban trolley. The inn and an adjacent building had to be demolished when the roads at the intersection were realigned.

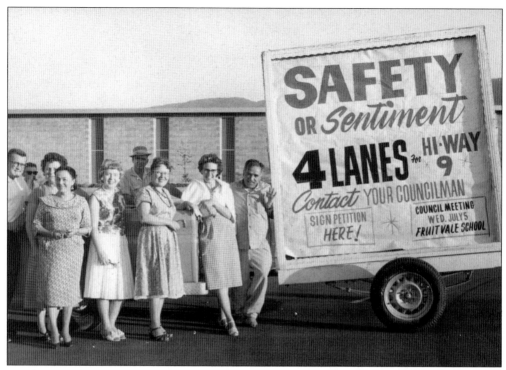

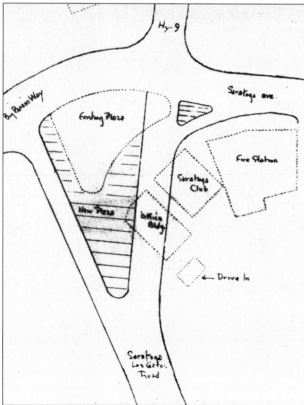

State Highway 9 has always been an important safety issue. Although the council voted down widening in the early 1960s, some residents petitioned for four lanes. At a public hearing, Mr. and Mrs. Robert Pitman, 13255 Saratoga-Sunnyvale Road, revealed there had been six fatal accidents in front of their home in the last 20 years. Saratoga citizens are noted for their active role in government.

A compromise was reached on a new alignment for State Highway 9 at the Saratoga crossroads near Blaney Plaza. Two structures were demolished, the Memorial Arch was relocated to a site next to the fire station, and Saratoga Plaza, also known as Blaney Plaza, was modified. The Memorial Arch returned to Blaney Plaza in 2006 after the new Saratoga Fire Station was built.

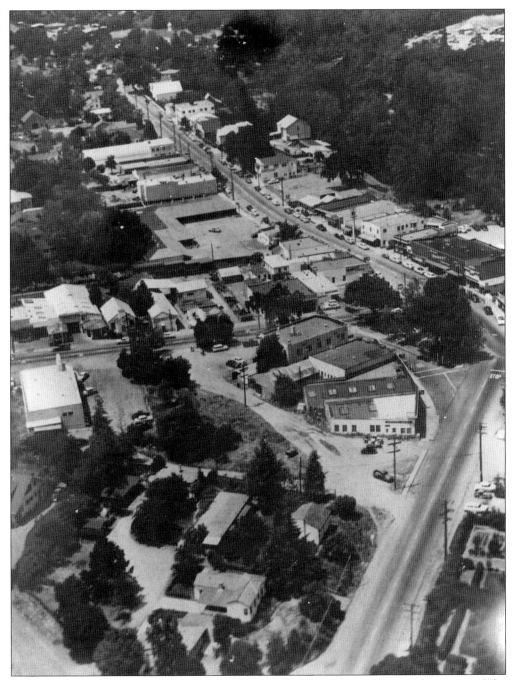

This aerial view of Saratoga Village from about 1952 shows Blaney Plaza in the center of the picture. The Beckham-Joslin Chrysler dealership is on the left, and the Methodist church seems to be without a steeple. The long curving street in the center of the picture that runs behind the fire station was once the right-of-way for the Peninsular Interurban, a trolley that ran from 1903 to 1933.

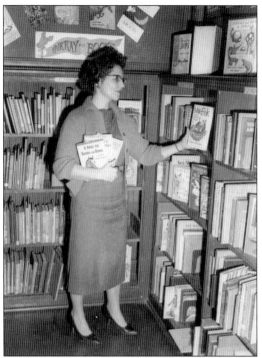

The Saratoga Library is one of the West Valley community's most important assets. Saratoga's citizens provide a library building, which is staffed by the Santa Clara County librarians. County librarian Lois Johnston is starting her new assignment by shelving materials in the children's section of the Village Library on Oak Street. The Saratoga community built a larger facility, and this wonderful old building, designed by Eldridge Spencer and now a national landmark, is currently operated by the Friends of the Saratoga Library as the Book-Go-Round.

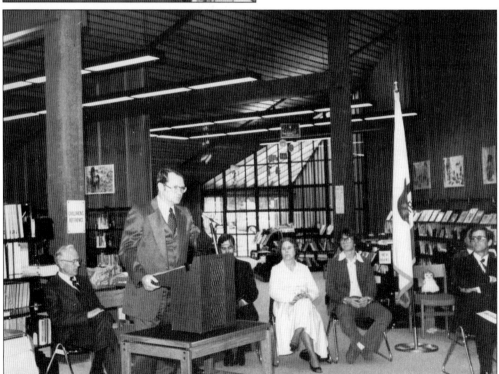

Saratoga residents built their new library building near the civic center, locating it in an orchard and designing the structure to recall a fruit-drying shed. The building was dedicated February 26, 1978. Here are various city and library board representatives at that dedication.

Six

ART, MUSIC, AND THEATER
SARATOGA'S CREATIVE SIDE

In early Saratoga, residents entertained each other. Both Hutchinson's Hall and Kane's Hall were used for concerts, dancing, and traveling shows. Local churches also held concerts that were attended by many who were not members of the congregation.

Saratoga Springs, near Long Bridge, was noted for its entertainments. The notable Tilly Brohaska and her all-girl orchestra was one of many groups who came to play for dancing. Like other small towns, Saratoga had a brass band, young men who played trombones and cornets. The famous musical *The Music Man* is an accurate picture of the pride small towns took in their local bands.

Two events after the start of the 19th century made Saratoga an important arts destination. The Blossom Festival was created in 1900. A retired Congregational minister, E. S. Williams, held a festival in thanksgiving for spring rains after several years of drought. This event was a great success. Local residents had their hands full, providing sandwiches and lemonade for visitors. When the new trolley line, the Peninsular Interurban opened two years later, the Blossom Festival brought thousands of visitors. By 1920, the festivities lasted a full week.

The second event was the creation of the Theatre of the Glade. The owner of the Saratoga Inn, Elizabeth Johnston, brought her daughter Dorothy from Broadway to entertain summer visitors. Dorothy Johnston and her friends presented plays beginning in the 1930s.

The young Johnston trained many local students, including Olivia De Havilland and Joan Fontaine. More than a dozen young people were launched on Hollywood careers by Johnston. Theatre of the Glade inspired two later theater groups, VITA, or the Valley Institute of Theater Arts, and the Saratoga Drama Group. VITA presented Shakespeare's works, and the Saratoga Drama Group presented modern comedies and musicals.

Artists enjoy Saratoga's scenery. One outstanding painter was Impressionist Theodore Wores, California's first native-born artist. Artist Bruce Porter made many local contributions and designed the Memorial Arch. Writers and poets associated with Saratoga include Gertrude Atherton and Kathleen Norris as well as George Sterling and Clarence Urmy.

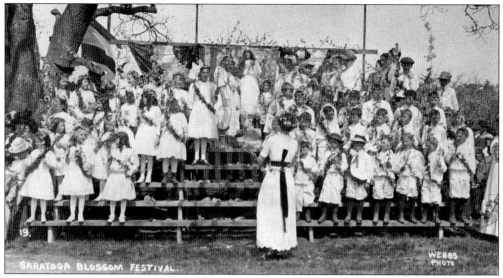

The Blossom Festival was an immediate success, and after the Peninsular Interurban trolley line was opened in 1903, hundreds of visitors came to the festival. Various events were staged over several days, and the entire enrollment of Saratoga School participated in the parades and pageants.

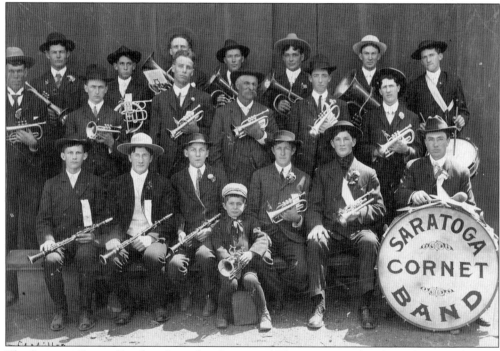

The Saratoga Cornet Band performed at the annual Blossom Festival and parade. Here they are with their fine instruments around 1905. From left to right are (first row) holding their clarinets, Vernon Lake, Burrel Melone, and Elton Hogg; Howard Walters, son of Henry Walters, (the group mascot); Lloyd Cox; Henry Melone; and Earl Melone with the bass drum; (second row) John Wolf; Earl Sieverson; leader Charles Miller; Henry Walter; Harry Tomlinson; and John Cox with his B-flat cornet; (third row) Walter Gregory; French Lake; Frank Miller; Albert Rowell; Elbert Stamper; Bert Young; and David Nerell with the snare drum.

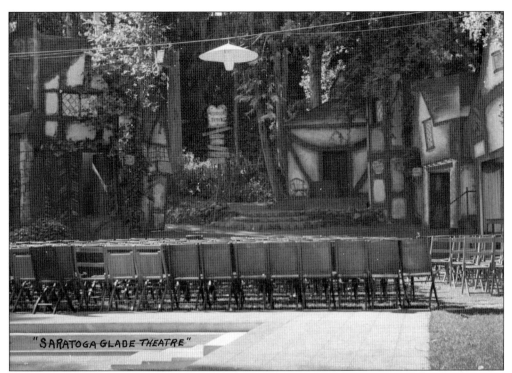

"SARATOGA GLADE THEATRE"

Theatre of the Glade was the creation of Elizabeth Johnston, owner of the Saratoga Inn. She convinced her daughter, Broadway producer Dorothea Johnston, to stage entertainments for summer visitors. The outdoor theater could seat several hundred patrons and presented Shakespeare's lighter plays.

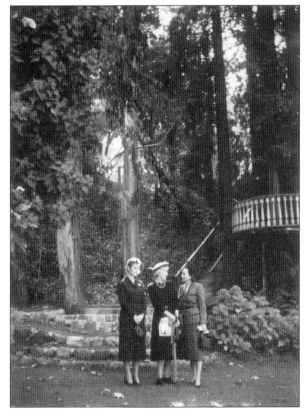

Olivia De Havilland visited Saratoga and took a nostalgic moment to look over the Theater of the Glade behind the Saratoga Inn. Standing with Olivia (right) are her first dramatics coach, Dorothea Johnston, and a best friend from Saratoga, Libby Goodrich Chamberlin (left). Libby was also coached by Johnston, and the two girls performed together in several productions.

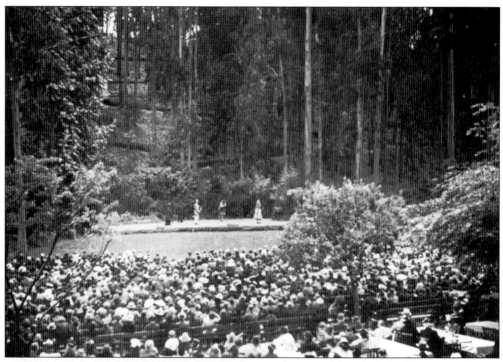

Theatre of the Glade had a spectacular venue, situated in a natural amphitheater that straddled Saratoga Creek. The site was located behind the Saratoga Inn and brought large audiences to the Saratoga area for outdoor performances.

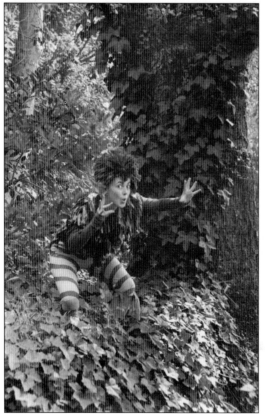

Olivia De Havilland appears impishly as Puck in a 1934 production of Shakespeare's *A Midsummer Night's Dream*. This play was staged outdoors by Dorothea Johnston in the Theater of the Glade, located next to Saratoga Creek.

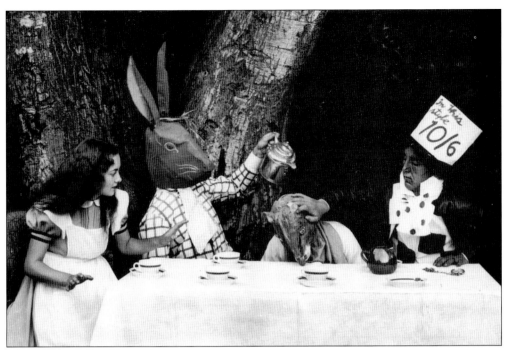

Olivia De Havilland began her
theatrical career in her early teens.
Here she appears as Alice in Dorothea
Johnston's production of *Alice in
Wonderland*. It was a production
with many notable locals. George
Lanphear played Humpty Dumpty
and the Two of Spades. Louise
Mendelsohn, later the owner of the
Plumed Horse Restaurant, was the
White Rabbit. Dorothea Johnston
took the role of the White Queen,
and Willys Peck played the Duck.

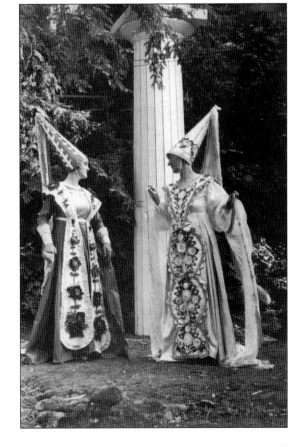

Producer Dorothea Johnston involved
many of her theatrical friends in her
productions. Two local designers
who helped her with costuming were
George Denison and Frank Ingerson.
This brilliant duo created these
stunning costumes out of paper.

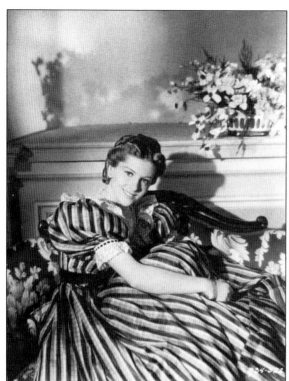

Joan Fontaine followed her famous older sister Olivia to Hollywood and also had an impressive career. She won an Oscar in 1942 for *Suspicion* and received two other nominations for her film work. She appeared in 70 films and has also acted in television and on Broadway.

Olivia De Havilland and Joan Fontaine both attended Saratoga Grammar School. Here is Olivia's eighth-grade photograph, the year she was the editor of the school newspaper. Olivia is at the end of the second row, second from left.

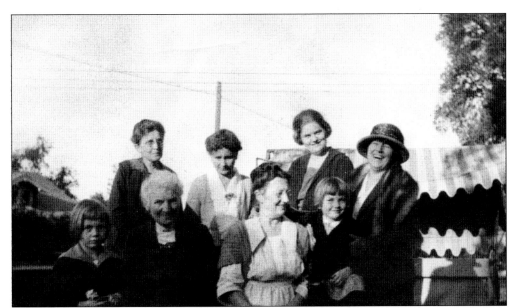

The Fontaine family moved to Saratoga and lived for a short time at Lundblad's Lodge on Oak Street, just a few doors down from the Oak Street School. Olivia is on the far left, and Joan is standing next to her mother on the right. Lillian Fontaine (far right) is enjoying herself immensely. Emma Lundblad and her daughter, Mrs. Hazel Bargas, are also shown with two of their friends.

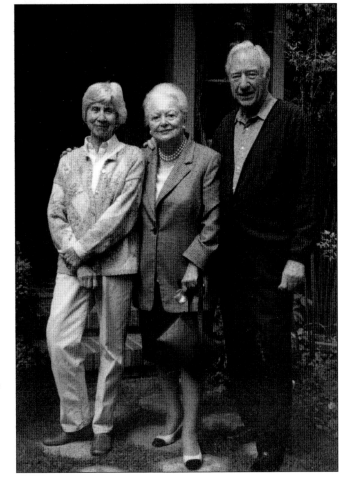

Architect Warren Heid and his wife, Sheila, bought the Fontaine family home on La Paloma. When Olivia comes to see her family home, she has the added pleasure of visiting with her old classmates from Los Gatos High School, Warren and Sheila. (Photograph courtesy of Warren and Sheila Heid.)

97

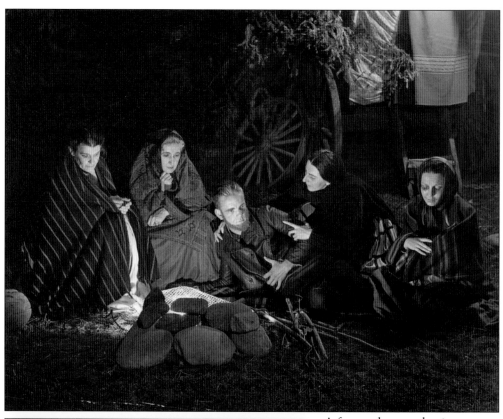

A few modern productions made it into the repertoire of the Theatre of the Glade. Director/producer Dorothea Johnston is second from the right in this dramatic offering entitled *Distant Drums*.

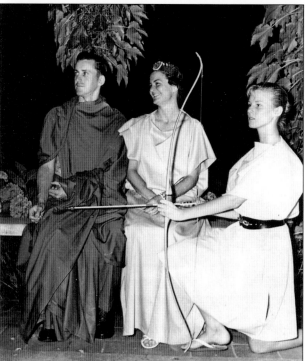

The theater behind the Willys Peck home has hosted dozens of theatrical productions. This summer production is appropriately *A Midsummer Night's Dream* and features John Cody as Theseus, Barbara Dusel as Hippolyta, and Ann Dusel as her young attendant.

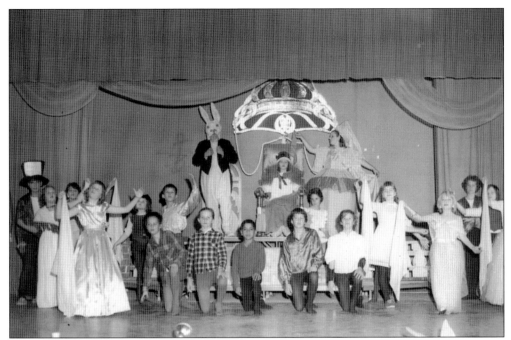

The Los Gatos–Saratoga Recreation Department offers theatrical training for young West Valley residents. Here is a 1961 production of *Alice in Wonderland* at the Los Gatos High School Auditorium, one of three performances of this favorite classic. Saratogan Claire Warfield danced and performed to great effect, and director Anthony Moyer was commended for the high quality of the cast.

A trio of famed soloists performs Baroque selections for the Music in the Vineyards around 1961, the first music offering of the season at the Paul Masson winery. These performances took place in the years when the Mountain Winery still had grapevines and was harvesting a crop.

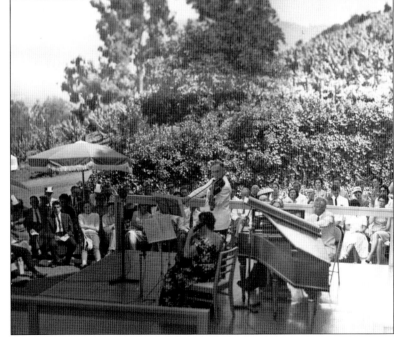

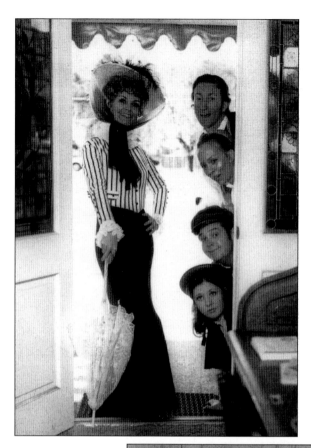

Hello Dolly was an extremely popular musical on Broadway, and it was just as popular in Saratoga with local talent. Lila Loyd plays Dolly Levi, the New York matchmaker, and her supporting cast, from top to bottom, is Milton Hayes, Becky Rodler, Wally Gilbert, and Melanie Hurley.

Musical productions take not only a tremendous amount of time to prepare; they need the various talents of singers, dancers, designers, and directors. Here the chorus is rehearsing for a show and has stopped for a moment for a publicity picture. Shows presented by the Saratoga Drama Group bring together talented people from all over the West Valley.

The Saratoga Drama Group presents both comedies and musicals, showcasing local talent of all ages. Here is a group rehearsing for a production of Steven Sondheim's *Follies* presented in 1986.

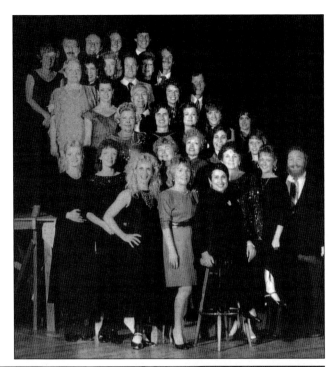

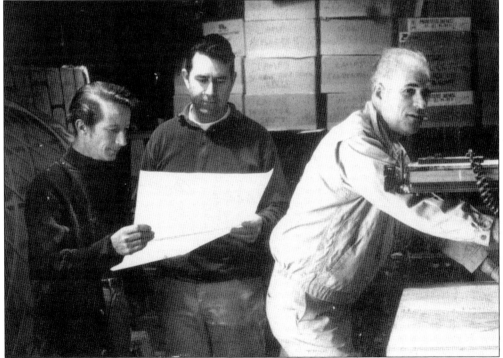

It takes as much talent and energy behind the scenes as it does in front of the sets. The Saratoga Drama Group depended on the design and craftsmanship to make the sets safe and sturdy as well as attractive. Here from left to right are Bob Lavender, Mac McCaughey, and Doug Anderson, building flats for one of their productions.

Villa Montalvo has always been a center for artists and those who support the arts. The outgoing officers of the Artists' Guild of Santa Clara County, retiring vice president Mrs. David Cassin and president Mrs. John Paulson, on the left, are meeting with the newly elected officers, Mrs. Charles Northrup and Mrs. Howard Beckley, on the right.

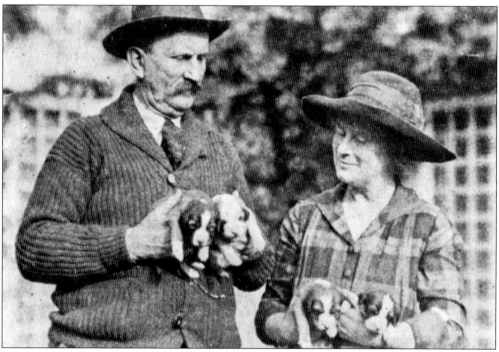

Fremont and Cora Older were one of the most interesting couples to live in the Saratoga area. He was known as a muckraking journalist from San Francisco, a newspaper editor who cleaned up corruption. She was a writer who was described as a literary lioness, a regular at Senator Phelan's literary soirees and a respected member of San Francisco authors' groups. Their summer home in Saratoga is named Woodhills and is still an important local attraction.

The Saratoga Museum owes its existence to Florence Cunningham, who served as chairman of the History Committee of the Foothill Club. In 1960, Florence invited Don C. Biggs of the California Historical Society to meet with local leaders and discuss forming a history society in Saratoga. The Saratoga Historical Foundation was incorporated in 1962.

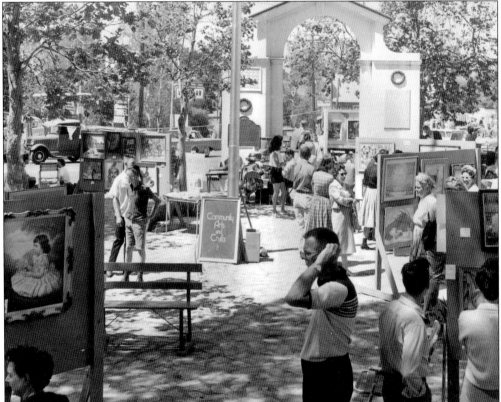

The first Saratoga Rotary art show was held in September 1959. The second was held in April, and the third fair, shown here, was held in June 1961. The fairs were a tremendous success and became the Rotary's major fund-raising effort for the year. Other communities have imitated the Saratoga show, now held on the first Sunday in May, but all participants agree that the Saratoga Rotary show is simply the best. This fair was held in Blaney Plaza.

Montalvo brings many important artists to their Saratoga studios for classes and shows. Student Charles McKee, on the left, watches a master potter, Antonio Prieto, as he works on a new piece. Montalvo is noted for its artists-in-residence program. (Photograph courtesy of Robert John Wright.)

William Dabelstein was the featured artist at Montalvo, exhibiting his California landscapes. Born in New York, he studied in Germany and the Beaux-Artes before coming to California. Commissioned to paint a panorama for the Panama Pacific International Exposition of 1915, Dabelstein later became a confirmed Westerner, specializing in landscapes of California. His works are included in many major galleries.

The Foothill 4-H Club won many ribbons and awards for their entries in the annual Santa Clara County Fair. Here are several princesses for the county fair: Judy Weber, Miss Cupertino, is kneeling in the front and petting a prize-winning Southdown lamb. Kathy Bentley, Miss New Almaden, is back left. On the right are Stephanie Macredes from Los Gatos and Miss Saratoga, Dina Hubbell, second row, who is holding a bunny. They are all prize winners.

Dina Hubbell, Miss Saratoga, pins an award to the lapel of R. V. "Vince" Garrod, chairman of the board of directors of the Santa Clara County Fair. Garrod was an extraordinary community leader, serving on the board of the California Apricot and Prune Growers Association, also known as Sunsweet, and helping to organize Farmer's Insurance Company.

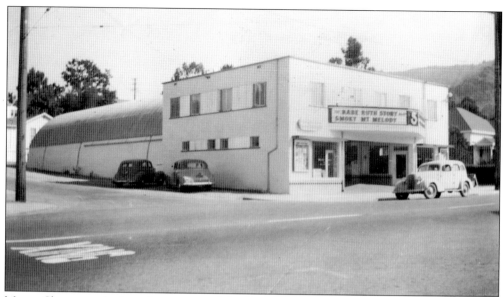

Mason Shaw was the longtime owner of the Saratoga Theater. Shaw also owned the Towne Theatre in San Jose and the Steinbeck Theater on Cannery Row in Monterey. He lived upstairs over the front of his movie house.

The Saratoga Theater, located at the corner of Big Basin Way and Third Street, was a military surplus Quonset hut built after World War II. There were two stories in the front; the theater lobby was on the ground floor, and the owner's apartment and projection room was upstairs. The building was demolished in the spring of 1965. (Photograph courtesy of Warren Heid.)

Seven

CHURCHES AND COMMUNITY
GIVING TO OTHERS

The religious beliefs of Saratoga's pioneers played an important role in shaping the community. William Campbell and Charles Maclay were both elders and lay preachers in the Methodist Episcopal church. They were ardent supporters of the temperance movement and abolition, the movement to end slavery.

The Santa Cruz Mountains behind Saratoga were settled in the 1860s by Catholic families from the Haute-Alpe area of France. These families built their little church in the hills near the Booker School above Long Bridge. Known as St. John the Evangelist, it was dedicated in 1890 and later consolidated with Sacred Heart parish.

For many years, there was tremendous tension between those who supported the temperance movement and the local winegrowers. Several of the hill families opened hotels in Saratoga Village and served wine, upsetting their temperate neighbors. But good sense and good manners seems to have prevailed as members of various congregations worked together.

An interesting illustration of community amity is the Saratoga Federated Church. Early local congregations always cooperated, as when the Methodist church celebrated the retirement of its building debt and Rev. Edwin S. Williams from the Congregationalist church and Dr. Eli McClish from the University of the Pacific helped officiate. The Congregationalist minister announced his strawberry social at the Christian church, and the Methodist minister supported attendance at Congregationalist concerts.

There were frequent discussions about combining the congregations or at least sharing a building. In 1919, six interdenominational study groups were held to explore the question. The Congregational and Christian churches came together to form a new church, and although the Episcopalians declined to join because of doctrinal differences, they did hold their services in the new Federated Church on a rental basis until 1940. So the Saratoga Federated Church is a unique combination of the community spirit that is a hallmark of Saratoga.

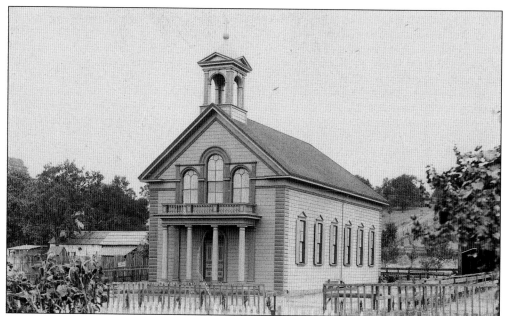

Sacred Heart Catholic Church is remembered as Saratoga's most beautiful chapel, completely built, inside and out, of the finest redwood available. The church was built and dedicated in 1885 and was sadly demolished in 1960. The site was later discovered to be the location of a Muwekma Ohlone camp, and many Native American artifacts were discovered in the vicinity.

The congregation of Sacred Heart Catholic Church dedicated a larger facility for their services, as the new hall and chapel on Saratoga Avenue are blessed. Bishop Hugh A. Donahue is officiating, assisted by the pastor of St. Mary's in Los Gatos, Rev. Peter Doherty, on the left. The pastor of St. Joseph's in Cupertino, Rev. Richard Ryan, is on the right. A new church building is also planned for the site.

The Sacred Heart social hall was a modest structure, but it served for 10 years until a larger church could be built. Today it is known as Geary Hall, named in honor of Fr. Gerald Geary, the first pastor of the modern Sacred Heart parish. Today Sacred Heart Church is a community landmark, and the bell tower can be seen far down Saratoga Avenue.

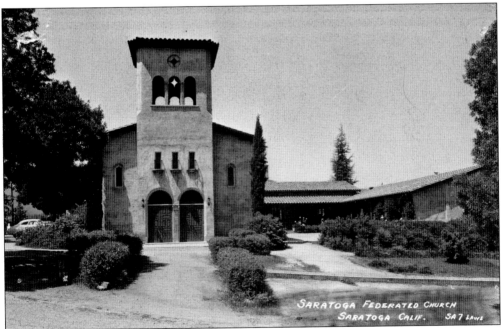

The Saratoga Federated Church, dedicated in 1924, is one of the community's most unusual congregations, housed in one of its loveliest churches. The building was designed by notable California architect Julia Morgan, a personal friend of one of the major donors. Morgan also designed the Foothill Club, located just across the street from the church. Artist Bruce Porter designed a stained-glass window for the church, and the organ was donated in memory of community leader Charles Blaney.

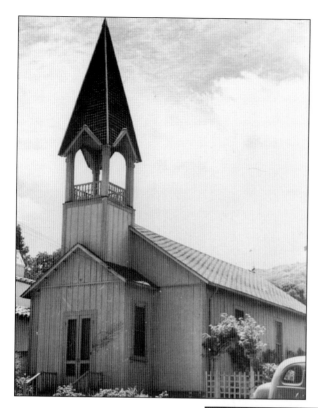

Saratoga was pioneered by members of the Methodist Episcopal church. A Methodist class was organized in the 1850s, but the congregation did not build a chapel until 1896. In 1924, the only Methodist church was sold to artist Theodore Wores, who used the church as a studio and gallery. Famous in his own time, Wores was California's first native-born artist. This image of the church shows it during the time it was Wores's gallery, and his sign is on the building front.

St. Andrew's Episcopal Church was organized in 1957 and met for two years in the IOOF Hall on Oak Street. The first building on their campus opened in 1959, and they dedicated their distinctive church building two years later. St. Andrew's was designed by Saratoga architect Warren Heid, AIA, and the interior was designed by Mark Adams. The Reverend Roy Strasburger was the vicar for 34 years, guiding the development and construction of St. Andrew's. (Photograph courtesy of Warren Heid.)

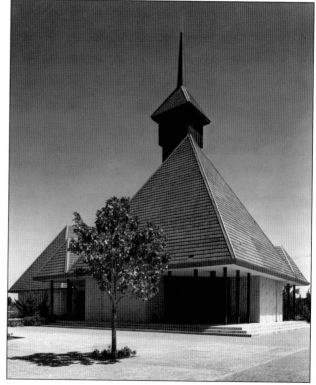

The Reverend George H. Emerson, a retired lawyer, was ordained to the post of deacon by Rt. Rev. James Pike, the Episcopal bishop of San Francisco, and is now raising the new St. Andrew's Episcopal Church flag. In the rear are the Rev. Roy W. Strasburger, the vicar, and Rev. Henry James, the associate vicar.

The Reverend Roy Nelson is opening the door to welcome people to the new auditorium of the Saratoga Avenue Baptist Church. The new building could seat 480, cost $80,000, and was designed by Lee Boldin. The church is located near the busy intersection of Saratoga Avenue and Prospect Road.

Prince of Peace Lutheran Church, located on Saratoga Avenue near Cox Avenue, broke ground on its new church in May 1960. The first pastor was Rev. Werner Welchert, who lived on Vanderbilt Drive. For the first few years, the congregation had met in the Odd Fellow's Hall in downtown Saratoga on Oak Street, so they were looking forward to holding worship services in their own church.

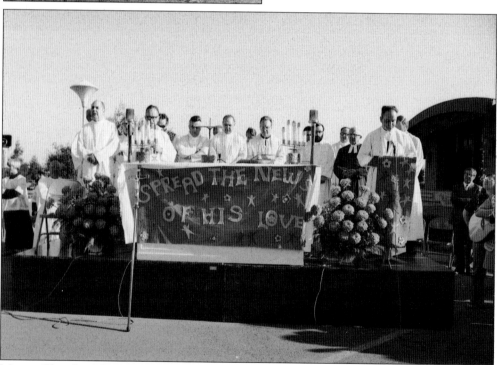

Mass at Church of the Ascension was offered on a new marble altar in the multipurpose church hall in June 1967. The pews were placed on runners so the building could serve social needs. Celebrating the opening are Archbishop Joseph T. McGucken of San Francisco and Fr. William Worner, the first pastor. (Photograph courtesy of Ed Metivia.)

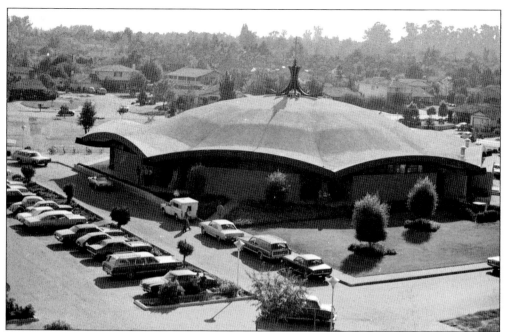

Church of the Ascension held its first services in a converted drying shed on Miller Avenue. Fr. William Worner was asked to take charge of a 13-acre site on Prospect Road and create a new parish for hundreds of new families in the area. Construction on the church began in 1966, and this spectacular structure was completed a year later. (Photograph courtesy of Ed Metivia.)

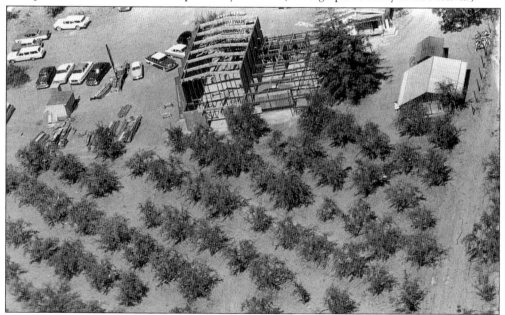

Grace United Methodist Church acquired a prune orchard on Prospect Road for their new church and built their sanctuary in 1960. The congregation has since moved on, and the property was purchased by the City of Saratoga for its future needs. The city tried to sell the property in 2006, but the old church was saved when local citizens put the issue on the ballot. Today the property is known as North Campus.

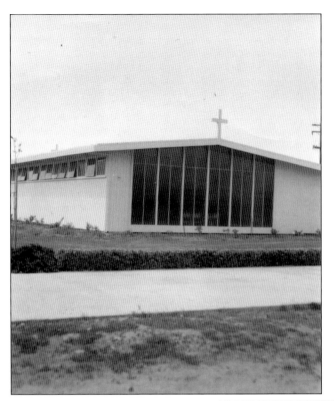

The Presbyterian congregations in the West Valley area were not well represented until well into the middle of the 20th century, when the Westhope Presbyterian Church was established. Rev. Loran Lewis was their early pastor.

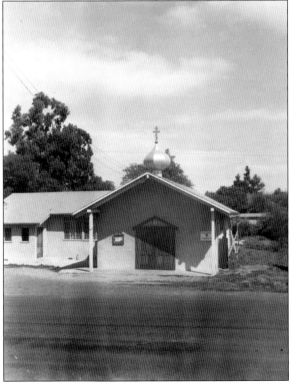

St. Nicholas Orthodox Church held its first services in the old offices of the Harless-Moser Real Estate Agency on Saratoga–Los Gatos Road around 1951. An immigrant born in Latvia, their first priest, Fr. Michael Zelneronok, found work at Montalvo as a gardener. The founding members of the church were families who had fled the oppression of Russian communism. The congregation found a site on Elva Avenue for their social hall and was able to complete construction of their church in the early 1960s.

Like many other local churches, St. Archangel Michael Serbian Orthodox Church found a building site for their new church in a prune orchard. The ground-breaking ceremony, which took place around 1960, was blessed by officials from the church. Fr. Dushan Bunjevic is on the far left, Fr. John Todorovich is in the long cope, and Bishop Dionisije is wearing the miter. Other participants are unidentified. (Photograph courtesy of Mary Bogdanovich.)

The Church of Jesus Christ of Latter-day Saints has a long history in California, beginning with the first ship-load of members who arrived in California in 1846. The church began plans for a building in Saratoga in 1963, and ground-breaking ceremony was held July 1, 1967. A large property on Allandale was chosen as a site. The ground-breakers shown from left to right are Ralph Anderson, Bernard C. Dove, Pres. M. Wilkins, Stanley Walker, and Ken Hartman, acting mayor. Members of the congregation participated in the actual construction of the structure. (Photograph courtesy of Mike Cummings.)

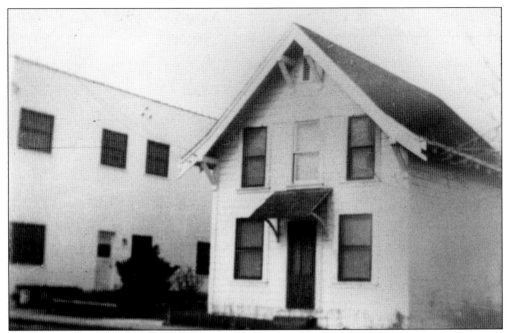

Saratoga is noted for being a very thrifty community as well as one that believes in making an effort to save its old houses. This little structure, identified as the Hartman House, was once a residence located near Fourth Street and Big Basin Way. It is also called the Grover House in memory of an early resident.

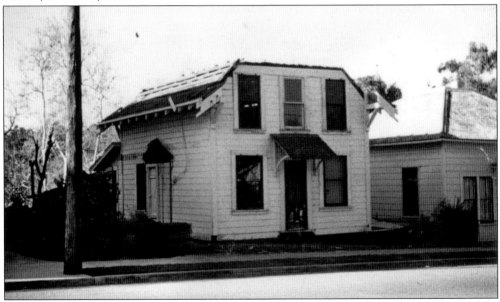

The Hartman house is just one of several village buildings that have been moved to save them from destruction. The old Swanee Dress Shop was relocated and became the Saratoga Museum; the McWilliams House was also moved and preserved. Two other local "gypsies" still located in the village are Judge Foster's house, moved from Marion Avenue, and a Victorian cottage now located on Sixth Street. That cottage was originally on Oak Street but was moved when the village library was built in 1922.

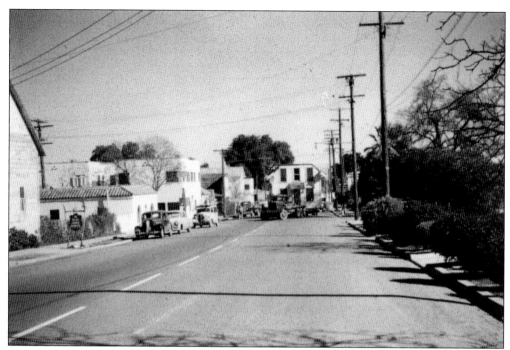

This little building, identified as the Hartman House, is being moved into place in its new location, only a block or so from its original home. Early Saratoga Village had many small frame houses such as this one amid the business buildings that faced Lumber Street. Many early business proprietors had their family home next door to their business establishment.

The Hartman House found a new life as the Christian Science Reading Room, a quiet place to sit and read the *Christian Science Monitor* or other newspapers of the day. In later years, the building was used as an antique store.

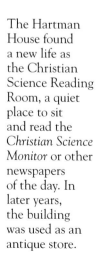

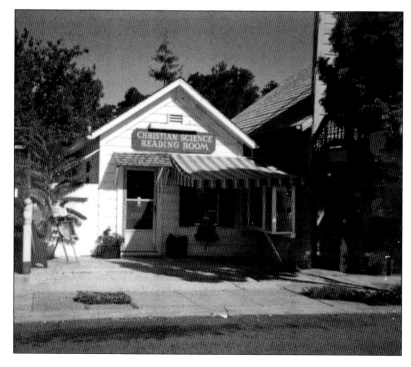

Christmas brings out the competitive spirit in some West Valley people and is an occasion to not only decorate the house and yard but to have a more spectacular display than all of the neighbors. Here is one portion of the prize-winning display of Mr. and Mrs. Paul S. Tarantino of 14080 Saratoga Avenue.

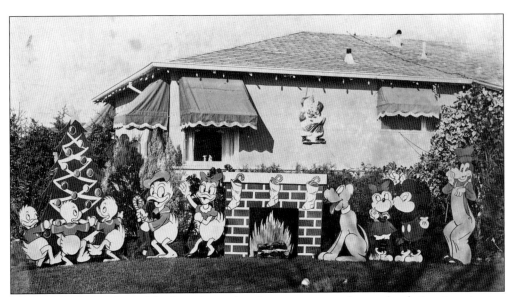

The Tarantino family used both traditional and contemporary themes for their prize-winning Christmas decor in 1958. In addition to their religious display, the decorations feature various Disney characters waiting for Santa. The contest was sponsored by the Saratoga Chamber of Commerce.

The Christmas tree in Blaney Plaza is a Saratoga tradition. For many years, the tree was harvested from the Santa Cruz Mountains, but in recent years, a living tree that is permanently located in the park has been decorated. Here the lights are being installed by the Saratoga volunteer firemen, fellows who have the very long ladders needed to do the job. Henry Clarke is helping Chief Gerald Renn as they position the tree with a block and tackle.

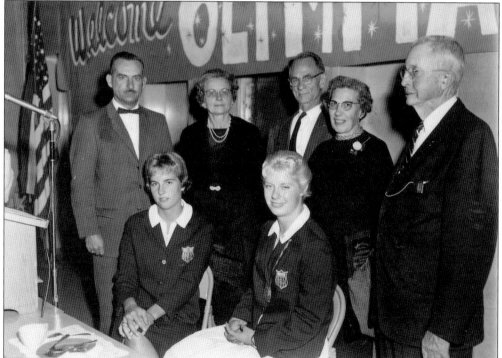

Mayor Burton Brazil presents plaques to medal winners from the 1960 Olympic Summer Games. Winners are Chris Von Saltza (first row, right), with three gold medals and one silver, and Ann Warner (first row, left), also a gold medal winner. In the second row are, from left to right, Dr. Burton Brazil, Mrs. Moore, Dr. Moore, Mrs. Hartman, and A. E. Merill, mayor of Los Gatos. Dr. and Mrs. Moore accepted for their son Mark, who won for rowing. Mrs. Hartman accepted a plaque for her son Jack, a bicycle-racing champion.

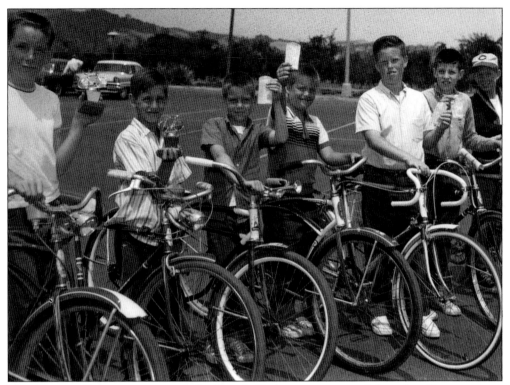

The Saratoga Optimists sponsored this Bicycle Rodeo to encourage bike safety. Young owners brought their bikes for a safety check and then demonstrated their riding ability. Forty young people participated, with Frank Kennedy and Max McKenva (far right) winning the first-place trophies. Medal winners were, from left to right, Doug Halderman, Jack Gillespie, Emerson Adams, Greg Johnson, and John James.

The Buy and Save Market, in conjunction with Ken-L-Ration pet food, sponsored an Amateur Kiddie Pet Show. Valerie Roberts won a trophy for her Chihuahua in the "Smallest Dog" category. She is being helped by Joe McCarthy, from the Ken-L-Ration Company, along with Hon. Richard Rhodes; the mayor, Dr. Burton Brazil; and Phil Ward, the principal of Argonaut School.

Saratoga Plaza is a gathering place, and these enterprising young residents hope to make a dollar or two from their lemonade stand. Saratoga Plaza is also known as Blaney Plaza in honor of real estate developer Charles Blaney, who donated land for a public park.

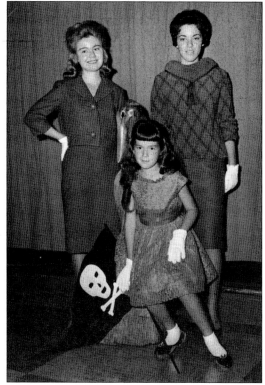

The annual fashion show held by the Ladies Guild at Sacred Heart Church is always a popular and profitable fund-raising event. Kathryn Rainie is on the left, Mary Kay Blumenthal is on the right, and the junior model in a lace party dress and gloves is Marianne Uzzardo.

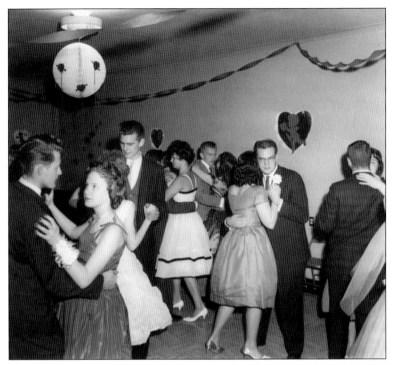

The Valentine's
Day dance in 1961,
sponsored by Sigma
Tau Theta Rho
Club of Saratoga,
was held in the
Fireman's Hall on
Oak Street. The
semi-formal event
was called "Cupid's
Capers" and was
well attended
by many young
Saratoga residents.

The store
at Saratoga
Springs was
an icon and
a destination
for more than
a century.
The store was
the center of
an important
community for
early settlers
along what is
now Sanborn
Road. The
last of the
important early
structures at
Long Bridge
burned in 1960.

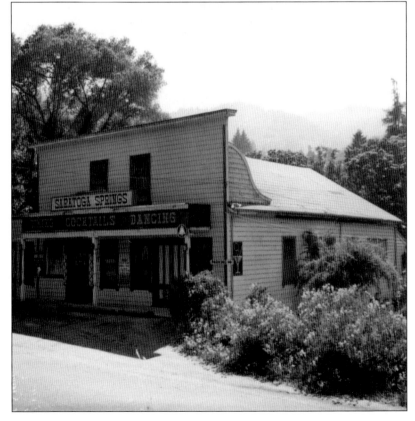

The annual Whist Party of the Saratoga Volunteer Fire Department was held in the new Saratoga High School cafeteria. Firefighter William Teeple is checking the raffle tickets of Mr. Pups, Mrs. L. D. Sailor, Mrs. Morton, and Carol Sinksen to see who wins the fur jacket. This was an important annual benefit event for the volunteers, held for more than 50 years. Whist is a card game very similar to bridge but is played by individuals rather than couples.

Dozens of prizes were donated by community merchants for the annual whist tournament, but the most spectacular prize was the fur coat donated by Panetta furrier. Mr. and Mrs. Fred Grevstad appear to be the very happy grand prize winners in this year's raffle.

Saratoga's Hakone Gardens were preserved for the enjoyment of all Californians through the efforts of a group of Chinese families and their friends. Joseph and Eldon Gresham, father and son developers, lived across from Hakone and were worried about its deterioration. They enlisted some of their fishing buddies, who formed an investment group that saved the garden. The group included John C. and Mary Young, the Greshams, George Hall, Dan Lee, and Johnny Kan. (Photograph by Johnny Kan, courtesy of Connie Young Yu.)

Every year, an outstanding community resident is named Citizen of the Year by the Saratoga Chamber of Commerce. Jack Mallory, chosen for this honor in 1994, a typical recipient, is shown here with his orchids. Jack is a former member of the city council (1980–1984) who volunteers on behalf of his community, his church, and his alma mater. He joins a distinguished group of recipients of this award. (Photograph courtesy of Sue Mallory.)

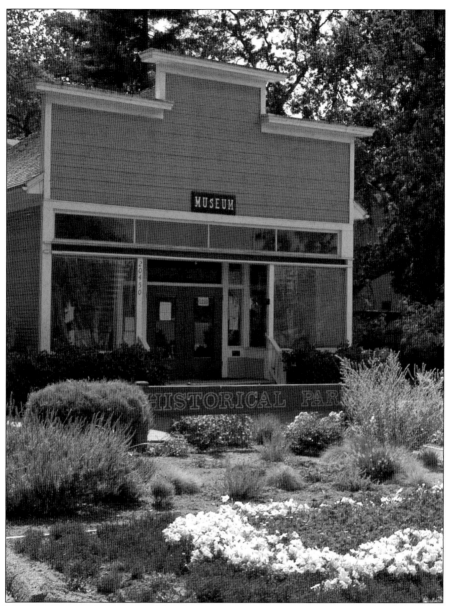

The Saratoga Museum, a pioneer false-front structure that was originally a hardware store and then a dress shop, was opened in 1976 to preserve the history of the community. The Saratoga Historical Foundation was organized in July 1960 and received its articles of incorporation in 1962. Members of the first board of directors were Arnold Loe, Clarence Neale, Harry Y. Maynard, Robert A. Mason, and Don McHenry. Additional directors included Louise Thompson, Mrs. R. V. Garrod, Mrs. R. F. Nylander, and Florence Cunningham. Florence Cunningham died in 1965 and left her collection of artifacts, the proceeds from the sale of her house, and the remainder of her estate to create a museum. Her wish was realized in 1975 when the Swanee Dress Shop and the McWilliams House were moved to the current site as part of the American Bicentennial Celebration. The museum was opened in 1976, and Melita Oden was the first curator. Visit the Web site for the Saratoga Historical Foundation at www.saratogahistory.com. (Photograph courtesy of Dave Anderson.)

BIBLIOGRAPHY

Allen, Rebecca and Mark Hylkema. *Life Along the Guadalupe River—an Archeological and Historical Journey*. San Jose, CA: The Press, 2002.

Arbuckle, Clyde. *Clyde Arbuckle's History of San Jose*. San Jose, CA: Smith and McKay Printing Company, 1985.

Clarke, Henry. *Henry Clarke's Saratoga Village*. Saratoga, CA: Unpublished manuscript in the archives of the Saratoga Museum, 2002.

Cunningham, Florence Russell; Frances Fox, ed. *Saratoga's First Hundred Years*. Fresno, CA: Panorama West Books, 1967.

Foote, H. S. *Pen Pictures from the Garden of the World or Santa Clara County*. Chicago: The Lewis Company, 1888.

Garrod, R. V. *Saratoga Story*. Saratoga, CA: Self-published, 1962.

Laffey, Glory Anne. *County Leadership: Santa Clara County Government History*. San Jose, CA: Santa Clara County Historical Heritage Commission, 1995.

McCaleb, Charles S. *Tracks, Tires and Wires: Public Transportation in California's Santa Clara Valley*. Glendale, CA: Interurban Press, 1981.

Munro-Fraser, J. P. *History of Santa Clara County, California*. San Francisco, CA: Alley Bowen and Company, 1881.

Nalty, Damon G. *The Browns of Madronia*. Saratoga, CA: The Saratoga Historical Foundation, 1996.

Peck, Willys I. *Saratoga Stereopticon: A Magic Lantern of Memory*. Cupertino, CA: California History Center and Foundation, 1998.

Sawyer, Eugene. *1922 History of Santa Clara County with Biographical Sketches*. Los Angeles, CA: Historic Record Company, 1922.

Thompson and West. *1876 Historical Atlas of Santa Clara County*. San Jose, CA: Smith and McKay Printing Company, rep. 1973.

In addition to books, the following maps and other local records were helpful:

Sanborn Fire Insurance Maps, microfilm.

Saratoga News. Los Gatos, California.

Saratoga Citizen. Saratoga, California.

San Jose Mercury News. San Jose, California.

INDEX

Across America, People are Discovering Something Wonderful. Their Heritage.

Arcadia Publishing is the leading local history publisher in the United States. With more than 5,000 titles in print and hundreds of new titles released every year, Arcadia has extensive specialized experience chronicling the history of communities and celebrating America's hidden stories, bringing to life the people, places, and events from the past. To discover the history of other communities across the nation, please visit:

www.arcadiapublishing.com

Customized search tools allow you to find regional history books about the town where you grew up, the cities where your friends and family live, the town where your parents met, or even that retirement spot you've been dreaming about.